THE
Archive Photographs
SERIES

BEDMINSTER

FROM

Moonlight on the Malago

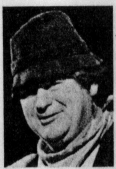

By the
Immortal Bard
Adge Cutler, Esq.

Fredal, Brendal, and Barbaral,
Used to make I 'eave a sigh;
Monical and sweet Veronical,
Each one I thought the one for I;
Until I met our Glorial,
From Bedminster, and there's no
doubt,
When it's Moonlight on the Malago,
Glorial and I goes out.

THE
Archive Photographs
SERIES

BEDMINSTER

Compiled by
Anton Bantock and members of the Malago Society

The MALAGO Society

TEMPUS

First published 1997
Reprinted 2000
Copyright © Anton Bantock and members of the Malago Society, 1997

Tempus Publishing Limited
The Mill, Brimscombe Port,
Stroud, Gloucestershire, GL5 2QG

ISBN 0 7524 1066 0

Typesetting and origination by
Tempus Publishing Limited
Printed in Great Britain by
Midway Clark Printing, Wiltshire

Further Reading

My Malago Book by Ron Cleeve (not commercially published)
South of the Avon: Glimpses of old Bedminster life by Leonard Vear (published by the author)
Bedminster Boy by Leonard Vear (Redcliffe Press)
Bedminster between the Wars by Leonard Vear
This House in Bedminster by Brian Jefferies
Miners Memories (published by CLASS, South Street School)
Water under the Bridge: memories of a Bedminster Man by J.H. Smith (Malago Publications)
Tell Your Mother There's a War On: Wartime memories of a Bedminster boy by Ted Hill (Malago Publications)
Where There's a Will: Rifleman W.J. Harris by Winifred and Norman Harris (Malago Publications)
A Tree Grew in Bedminster: a family anthology by Ivy Herwig and Winifred Harris
Bedminster's Victorian Heritage No. 1 by Anton Bantock (Malago Publications)
Bedminster's Victorian Heritage No. 2 by Anton Bantock (Malago Publications)
Remember Bedminster (published by Windmill Hill City Farm memories group)
Malago magazines (Malago Publications)

Cross reference to articles have been included in square brackets after the captions using the abbreviation, M.x - *Malago* magazine number x. Much more unprinted material on old Bedminster exists in the Malago Archives. Most of the photographs come from the extensive photographic archives accumulated and catalogued by the Malago Society. Access to the archives and photographs is by application to the Society via Bishopsworth Library.

Contents

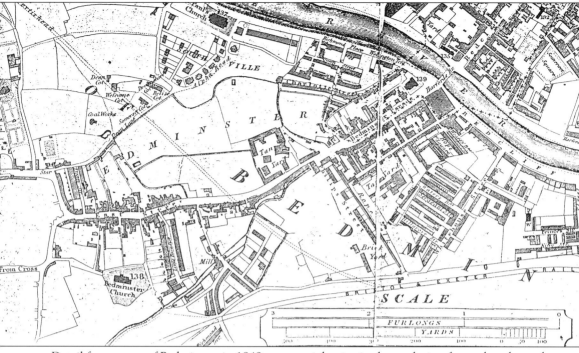

Detail from a map of Bedminster in 1849, at a crucial point in the evolution from a largely rural community to a seething industrial suburb of the City of Bristol. Twenty years later the whole of the area covered by this map was urbanised. 1849 was the year of a serious cholera epidemic in which 226 died in Bedminster, mostly in the fetid courts and alleys bordering Bedminster Parade. The map shows the route of the Portishead branch line, as originally projected. In fact it was not built until 1867 and ran through Ashton Vale. The original route was used as a tramway for coal trucks between Dean Lane Colliery and East Street until the 1890s.

Acknowledgements

The Malago Society would like to thank all those who have contributed photographs, especially Mr John Langbridge of Somerset Terrace, Windmill Hill, who has allowed us to consult over 200 of his splendid Bedminster photographs; Mr Mike Tozer; Mr John Winstone; Mr Bob Williams; Mr Mike Hooper; Mr Robert Willis; Redcliffe Press; Bristol City Museum and Art Gallery; Bristol Record Office; Somerset Records Office; Bristol United Press Ltd; St Mary Redcliffe Church; the *Remember Bedminster* memories group. Unless indicated otherwise all maps and diagrams are by Anton Bantock. We would like to thank all those who have contributed to this telling of the story of Bedminster, whether by working on the book, supplying photographs over the years, mining the archives or recalling their own experiences and those of their families and friends.

Introduction

Bedminster is Bristol's famous southern suburb. For many centuries it was a separate town and until 1831 in the county of Somerset. Its history is older than Bristol's; when Bristol was little more than a river crossing, Bedminster was already an important township. The origin may be Roman – its main thoroughfare, East Street/West Street, is certainly Roman – and the mission church of St John's predates any Christian foundation in the city. The fast-flowing Malago drove water-mills (three survived up to the twentieth century) and provided fresh water; and mill pools were ideal for baptising the heathen. The ancient British or Welsh word for baptism, *bedydd*, may have given the place its name; and *melis* (mill), *agos* (place), could explain the origin of the name Malago.

The priests of St John were accorded the special status of 'prebendaries', and a place for the Prebend of 'Redcliffe with Bedminster' is reserved in the choir of Salisbury Cathedral to this day. In the twelfth century, St John's became the mother church of St Mary Redcliffe and Abbots Leigh, and of chapels of ease at Bishopsworth and Knowle. Even to this day, communion in Abbot's Leigh begins five minutes past the hour to give more time for the priest of St John's to toil up Rownham Hill. William of Wykeham and Henry Chichele, Archbishop of Canterbury, began their careers in Bedminster. Edward Powell, vicar in 1536, was hanged at Tyburn for refusing to take the Oath of Supremacy to Henry VIII.

The Royal Manor of Bedminster comprised all the land south of the Avon from the Gorge up to Brislington, and according to the *Domesday Book* had 25 villains, three slaves and 27 smallholders with ten ploughs, one cob, nine cattle, 22 pigs and 115 sheep. It was bestowed by Norman kings on royal and powerful magnates and became finally a fief of Robert FitzHarding, *c.* 1130, who in 1154 was awarded the barony of Berkeley and founded the Manor of Berkeley. For over 300 years the lords of Berkeley preferred their fair Manor of Bedminster to the gloomy fortress on the Severn and as such played a prominent part in the development of Bristol, fostering trade and founding abbeys and churches.

Berkeley power waned in the fourteenth century, and after 1416 their Manor of Bedminster passed to heiresses and their families. It was finally purchased in 1605 by the Smyths of Ashton Court who continued to be lords of the manor until their feudal powers fell into abeyance in the nineteenth century.

Up to the seventeenth century Bedminster was a prosperous community clustering round its parish church in a fertile and well-watered valley. In the 1630s it was assessed for ship money at £47 13s 4d which establishes its economic equality with Glastonbury (£56) and Frome (£49). The town was sacked and burnt in 1644 by Prince Rupert before the second siege of Bristol and it took over a century to recover. When John Wesley preached at the Paddock in the 1760s, Bedminster was a sprawling and decayed market town, with orchards rubbing shoulders with brickworks, rope-walks and cottage industries.

But a dramatic change was just round the corner. Open-cast coal-mining was first reported in the 1670s; in 1744 Jarrit Smith, who was to become Sir Jarrit Smyth of Ashton Court, called in a mining surveyor from Kingswood and the first shafts were sunk at South Liberty Lane in 1748. Sixty years later there were eighteen coal-pits operating in the Bedminster and Ashton Vale coalfield. Not only did the Smyth family do very well from the royalties, but on the threshold of the industrial revolution Bedminster had coal and easy access to the city docks and the insatiable demands of a growing city.

The transformation of Bedminster was rapid and traumatic. The population jumped from 3,000 in 1801 to 78,000 in 1884, as people from depressed rural Somerset flocked to the new coalfields for work. Almost overnight Bedminster became a power-house of heavy industry

manned by a huge workforce packed into high-density terraced housing. Coal mining and smelting generated other industries: engineering, tanneries, glue-works, paint factories, glass-works. In the 1880s, E.S. & A. Robinson's paper-bag business and W.D. & H.O. Wills' tobacco business moved to new factories in Bedminster.

The development was too rapid to implement the kind of urban infrastructure necessary to prevent slum conditions. In the middle years of the nineteenth century the authorities faced public health problems of monumental proportions. In the filthy courts and alleys of Bedminster the cholera epidemics of 1830 and 1846 caused more fatalities than anywhere else in Bristol.

Bedminster had by the 1870s overflowed to the surrounding hills and hollows creating its own suburbs on Windmill Hill, Totterdown, Southville, the Chessels and Bedminster Down. Although brought finally within the city boundary in 1897, the construction of the New Cut of the River Avon (1804-09) ensured that Bedminster remained geographically separated from the rest of Bristol. Bedminster not only has its own dialect, but its own vocabulary and its own sense of humour. Those who encounter some Bedminster folk for the first time find a genuineness and warmth and a robust, yet gentle personality which has no parallel.

There is no doubt that the new industries generated considerable wealth, and in the years up to the First World War the shops and businesses lining the old thoroughfares of East Street, West Street and North Street had a glamour and reputation which are remembered with pride and affection today when so much has disappeared. As government, church and private enterprise raced to catch up with the needs of a huge population, so Bedminster was graced with an abundance of schools, chapels, pubs and institutional buildings, many of which survive in all their Victorian glory. Even street furniture – lamp-posts, tramway-cable carriers, public lavatory railings, ventilators and man-hole covers – were stamped with those hallmarks of the nineteenth century, quality and durability.

In the years 1880 to 1930, Bedminster's population and prosperity peaked. Its pubs multiplied and did a roaring trade. Church and Chapel competed; services were packed and brotherhoods and sisterhoods shaped the quality of life of whole generations. No words or pictures can ever capture the community spirit that flourished in the poor and crowded back streets. It finds expression today in the memory of those old enough to remember, in the lively and well-attended clubs of senior citizens, and in nostalgic publications like *Remember Bedminster* and *Malago* magazine. Bedminster's terraced streets received a terrible pounding in the air-raids of 1941-44 and post-war planning removed most of the industries and resettled whole districts in the new estates of Highridge, Hartcliffe and Withywood. By the 1970s Bedminster had declined to an inner-city twilight zone. But much of the fine nineteenth-century architectural landmarks remain and on Windmill Hill, Totterdown and Southville its charming terraced houses survive intact.

After 1980 the city planners paid tribute to this by pedestrianising part of East Street and furnishing it with pretty bricks and bollards and lamp-standards which complement the exuberant architectural heritage of the nineteenth century. The decline has been halted. Cleared areas have been imaginatively redeveloped. An influx of newcomers is bringing new life and character: Windmill Hill City Farm, the Off Centre gallery, the Lam Rim Centre, the 'Show of Strength' Theatre Company which started at the Hen and Chicken, The Greenhouse. ASDA has taken the place, and in some respects revived the functions, of the old Wills cigarette factories. On Friday afternoons and Saturday mornings some of the old magic returns to East Street. The lives and achievements of Bedminster folk encapsulated here in photo, word and drawing will help to ensure that the spirit of Bedminster will live on and enrich future generations.

The pictures are arranged broadly chronologically and are grouped by theme. There are no formal chapter breaks; the Contents on page 5 show a broad indication of how the story of Bedminster progresses through the book.

One
The Bedminster Story

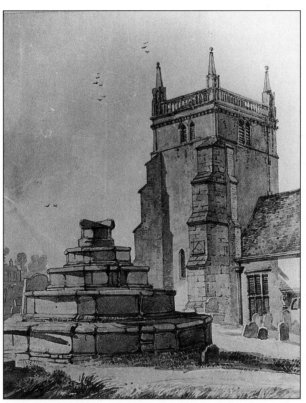

Water-colour of St John's, *c.* 1820, a church whose foundations may be older than any in Bristol. This is the site of the minster or mission church from which Bedminster takes its name. The name 'Bed' may derive from *Beda* or *Bede*, a fairly common Saxon name; or it may come from the ancient British (Welsh) word *bedydd*, meaning the place of baptism. The base of the ancient preaching cross has survived many rebuildings of the church and is still there today though the church and churchyard have all but disappeared. [M29, M32].

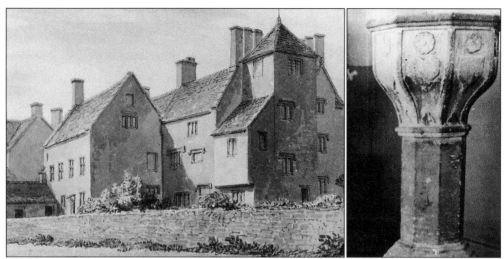

Left: Water-colour of Lower Knowle Court, *c*. 1820. Probably the original manor house of the manor of Bedminster which from the twelfth to the fifteenth centuries was a principal residence of the Fitzhardings (or Berkeley) family. The Smyths of Ashton Court acquired the Manor of Bedminster in 1605 and the house remained in their possession until the eighteenth century. It subsequently became a farm, was progressively dismantled, and a single wing survives to this day, boxed in by 1930s housing and called 'Clancey's Farm' after the last family to farm it (St John's Crescent). [M17, M29, M30]. *Right*: Fourteenth-century font of St John's. Removed from the church *c*. 1855 and finally rescued from Mr Phippen's garden; resurrected for St Werburgh's Mission Church, Lynton Road, in the 1950s. Disappeared into the undercroft of St Mary Redcliffe and has finally come to rest in the St John's chapel at this church. [M15].

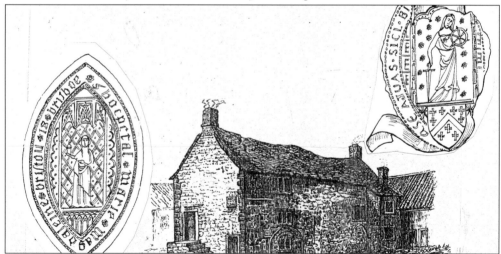

St Catherine's Hospital. This was founded by Robert de Berkeley *c*. 1200 at Brightbow between Bedminster and Redcliffe to provide victuals and accommodation for pilgrims travelling to Glastonbury. The seal shows St Catherine and the wheel on which she was crucified. The other seal is that of the Leper Hospital, St Mary Magdalene, for leprous women, which was mid-way between Brightbow and Redcliffe. These religious houses survived the dissolution of the monasteries and were eventually closed *c*. 1572 in the reign of Elizabeth I. The buildings became a glass works, then a tannery and were finally cleared for the building of the W.D. & H.O. Wills factory in 1887. [M16].

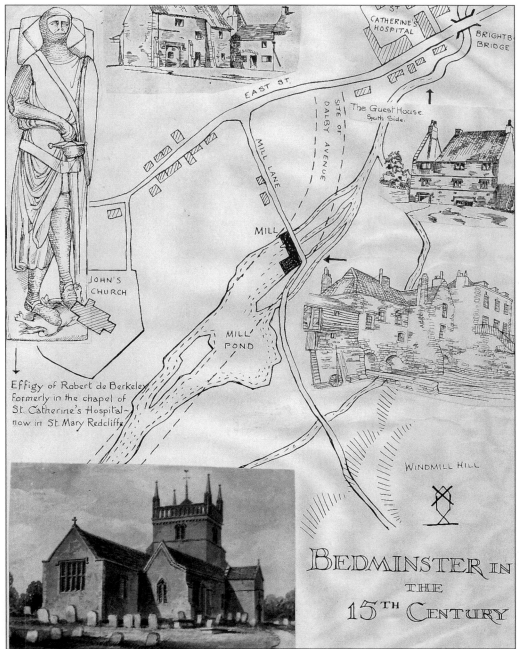

The two drawings of the guest house of St Catherine's Hospital were made by the antiquarian, Father Ignatius Grant of St Mary's on the Quay shortly before St Catherine's was demolished in 1887. St Catherine's Mill carried Mill Lane over the many channels of the Malago to the hospital's windmill which gives the hill its name. The windmill survived until the early nineteenth century, the water-mill until the 1890s. The names Catherine Mead Street and St Catherine's Place (shopping precinct) are all that remain of the former glories of St Catherine's Hospital.

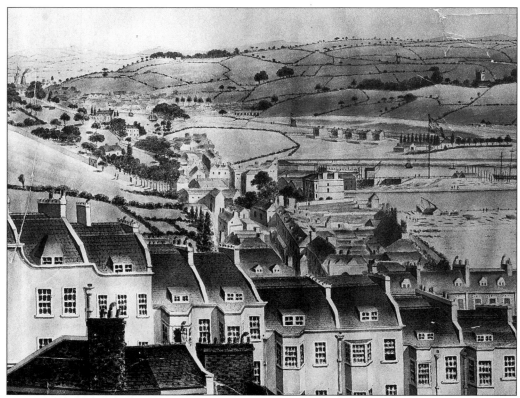

Panorama made by the Royal Engineers, *c.* 1811, from Granby Hill, Clifton. In the middle distance, Cumberland Basin can be seen and, beyond, the New Cut of the River Avon constructed 1804-1809. Concealed by rising ground south of the New Cut is the village of Bedminster. Only the church of St John's is visible on the hills behind the Windmill. Extreme left is Redcliffe and, marked by a line of trees, Bedminster Causeway and the new housing south of the river (Whitehouse Lane and York Road).

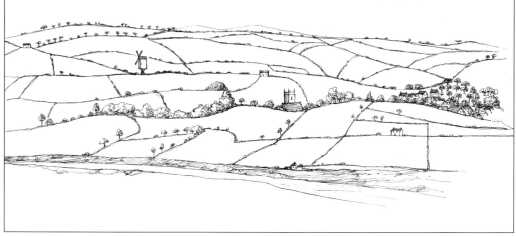

Drawing taken from the above panorama showing the earliest-known illustration of Bedminster. The Windmill stood until the 1820s and gives Windmill Hill its name. [M26].

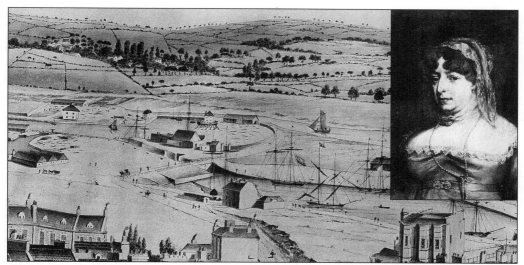

Continuation of the panorama showing (top left) the cottages and farms of Bedminster surrounded by trees and fields. Extreme left is Clift House, an imposing mid-eighteenth-century mansion with views down the Avon Gorge. It was surrounded by a magnificent garden and a perimeter wall; part of it still exists at the end of Coronation Road (opposite Frayne Road). In the early nineteenth century it was the Dower House of Ashton Court and the residence of the eccentric Lady Elizabeth Smyth. Clift House ended its days as a sanatorium, was demolished *c.* 1935 and is now the site of bonded warehouses and the Riverside Garden Centre. [M25, M26, M28]. *Inset*: the Dowager Lady Elizabeth Smyth.

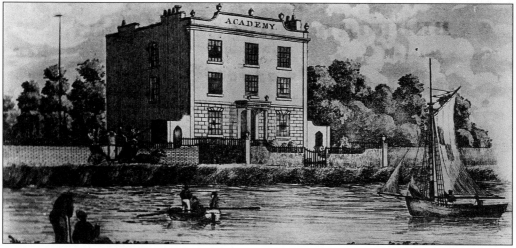

Bedford House Academy may well have been the first building in Coronation Road. In his prospectus Mr Hewlett offered for 22 guineas per annum a 'comprehensive course in English Grammar, with accurate and critical parsing, the classics, composition, merchants' accounts, Geography and the construction of maps, Astronomy and the use of globes, practical surveying and mapping of land, History, Chronology, etc.'. The young gentlemen were to 'take their meals with Master, [were] treated with affectionate and parental tenderness and experience every comfort in common with the family.' In practice such institutions invariably fell far short of these pretentious claims and became notorious places of detention for unwanted children of wealthy parents.

Part of a Panorama by T.L.S. Rowbotham in the 1830s. This section shows St John's Church from what is now Victoria Park. The terraced cottages, bottom right, are now Whitehouse Street and beyond that is the first block of industrial housing extending to Bedminster Causeway. To the right, on a hilltop and surrounded by trees, is Merrywood Hall, now Southville Primary School. On the horizon is Ashton Hill and, beyond, Failand Hill.

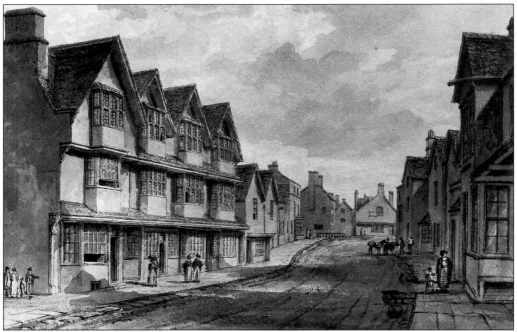

East Street, *c.* 1830. The fine seventeenth-century timber-framed houses on the left survived until the 1880s and appear in historic photographs in Reece Winstone's *Bristol as it was 1874-1866* [sic]. They stood on the corner of East Street and St George's Barton, now Church Road. The three-storied house further up was Church House, home of Robert Phippen (*see p. 117*). The old London Inn (centre) was situated several yards to the east of the present structure and blocked the entrance to Back Lanes (now British Road).

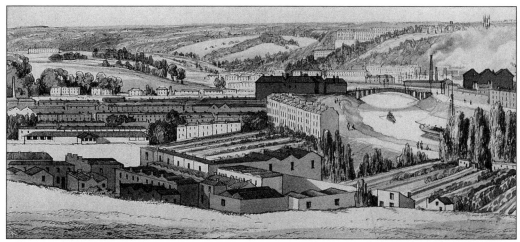

The adjoining section of Rowbotham's panorama shows the new terraced dwellings in the angle of Bedminster Causeway (Bedminster Parade) and York Road on the New Cut. Stately three-storied late-Georgian houses were beginning to appear on the soil thrown up by the digging of the New Cut. The first Bedminster Bridge, an elegant cast-iron structure, horrified Brunel because of its faulty design. When rammed in 1860 by the *Fanny Chapman*, the arched ribs partially telescoped. It was replaced by the present structure in 1880. In the foreground is Prince Street (rebuilt in the 1860s as Princess Street). Top left is Ashton Court and, to the right, the grand terraces of Clifton and, on the horizon, Clifton parish church.

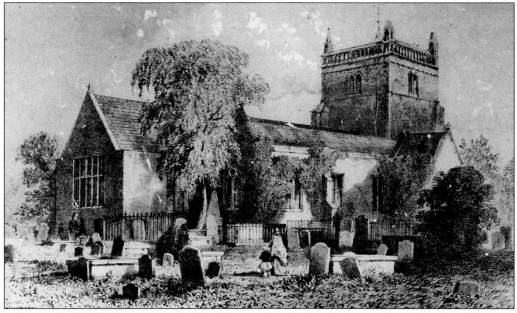

Lithograph of St John's, *c.* 1850. This fine medieval church, the mother church of St Mary Redcliffe and Abbots Leigh, had been severely damaged before the second siege of Bristol in 1645 and was rebuilt in a debased Gothic style in the 1660s. By the middle of the nineteenth century it was in a neglected and dilapidated state and quite inadequate for the needs of the growing population which had increased from 3,287 to 19,421 between 1801 and 1851. [M4, M35, M36].

Sir John Smyth, baronet (d. 1849) of Ashton Court was the Lord of the Manor of Bedminster. He was a sinister, misanthropic bachelor who surrounded his estate with an intimidating, five-mile wall and shunned human companionship because, it was said, he was suffering from an unmentionable disease which made him smell very offensively. As Lord of the Manor of Bedminster he was responsible for the maintenance of the chancel of St John's Church but although he was the second wealthiest landowner in Somerset, he did nothing for the church. Joseph Leach, journalist and sermon taster, taunted Sir John in the *Bristol Times and Mirror*. 'Don't raise your hands Sir John; don't shrug your shoulders Sir John; I say you ought to do it [repair the church] since the parish will not! Out of your thousands a year you would not feel the comparative little required to set the sacred edifice in order. If you let me know the day, I'll be happy to borrow the key and take you through the church and show you the woodwork rotting and the roof threatening and the green mould gathering here and there.'

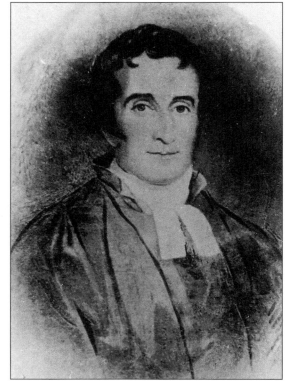

Revd Martin Whish was little better; he was the spoilt son of a former vicar of Bedminster, Revd Richard Whish, living in some luxury with his mother in a grand house in Redcliffe and neglecting his duties. Joseph Leach did not spare him: 'Prebend of Sarum, Vicar of Bedminster and Abbot's Leigh, incumbent of Redcliffe and St Thomas! I have a crow to pluck with you; how comes it to pass that you leave a parish of eleven thousand souls without a church? Are the two sermons you pull out of your pocket on Sundays sufficient for the other six days they never see you? No wonder the place be full of dissenters; no wonder that when I passed through your parish on the Sunday of my visit I heard them thumping and thundering from back rooms and attics in streets and by-ways – colliers and carters making themselves heard by all who went by through the strength of their lungs, and the vehemence of their language.'

Bedminster, July 26th, 1832.

Notice is hereby given,

That the Churchwardens and Overseers of the Parish of Bedminster intend

PERAMBULATING

The Boundary intersecting the

PARISH OF BEDMINSTER,

Prescribed by an Act of Parliament, made and passed in the Third Year of the Reign of King William IV. which subdivides the EASTERN DIVISION of the COUNTY of SOMERSET from the City & County of the City of Bristol.

The Division in Reference to the Parish of Bedminster is as follows:—

"Along the Boundary of the Parish of St. Philip and Jacob to that point thereof which is nearest to the point at which the Wells Road leaves the Bath Road; thence in a straight line to the said point at which the Wells Road leaves the Bath Road; thence along the Wells Road to the Knowle Turnpike Gate; thence along the Road which leads from the Knowle Turnpike Gate to Bedminster Church, to the point at which the same is crossed by Bedminster Brook; thence along Bedminster Brook to the point at which the same crosses the Road from Lock's Mill to Bedminster; thence along the last-mentioned Road, passing the Southern extremity of the Village of Bedminster, to the point at which the same meets the Brook at Marsh Pit; thence along the last-mentioned Brook to the point at which the same meets the Boundary of the Parish of Clifton."

All Persons who are desirous of accompanying the Parish Officers

A TRUE AND PARTICULAR ACCOUNT OF

AN ATTEMPT TO ROB

BEDMINSTER

Church-Yard,

Of a Female Body,

Early this Morning, (Saturday, November 2, 1822,)

AND THE APPREHENSION OF

FIVE OF THE

DOCTORS.

Early this morning, Eight men, including several Doctors, entered the Church-yard of Bedminster, near Bristol, and began their nefarious work of plundering a grave where-in a body was interred on Sunday last, who had died at the Infirmary.---She was considered a fine *Subject*, and the Doctors were determined to have her at all events.---They had nearly succeeded in *raising the dead*, when Mr. Yates, of the Lamb Inn, and several other Constables, who perambulate the Streets of Bedminster, nightly, as Patroles, entered the Church-yard, and discovering what was going

Left: the problems of the parish were left to the hard-pressed parish officers whose names appear on this notice advertising the perambulating of the parish boundaries. It was customary to thrash little boys and bounce little girls on the boundary markers to make them remember them; for before the development of local government, the parish was the principal unit of administration for the assessment and collection of rates, the operation of poor relief and the allocation of police duties. [M25]. *Right:* the parish officials succeeded in disturbing body-snatchers at their work and wounded one of them, described as a doctor but more likely a medical student. There was an acute shortage of fresh corpses for anatomical research and instruction and much money could be made from their grisly trade.

ALPHABETICAL LIST

OF

PERSONS & FAMILIES who receive WEEKLY RELIEF from the PARISH of BEDMINST[ER]

Ages.	Children under 9 Years.	Names.	Description.	Per Week.	Residence.
		A		*s. d.*	
47	2	Attwood, Sarah	Widow,		Somerset street
	4	Andrews, Mary		5 0	Coach and horses court, Broadmead.
22	1	Aldridge, Ann	Widow,	2 0	No. 11, Somerset street.
2—26	4	Adams, Thomas and wife	Labourer,	4 0	Bedminster terrace.
		B			
38	3	Biggs, Henry and wife	Labourer,	1 6	James's court.
		Boyle, Isabella	Widow,	5 0	Bright's bow.
3—27	1	Bennett, George and wife	Cordwainer,	2 6	Southley's paddock.
9—22	1	Bragg, John and wife	Cordwainer,	1 6	Tennis court, Redcliff parish.
		Bliss, Thomas and wife	Accountant,	4 0	Lewin's mead, Bristol.
5—65		Barret, Thomas and wife	Labourer,	1 6	Water street, st. Paul's.
64		Bishop, Salome	Washerwoman,	1 6	Burdett court.
6—76		Burge, John and wife	Sawyer,	5 0	Bagg's court.
73		Bradgate, Ann	Widow,	3 0	West street.
		Baker, Catherine	Widow,	3 0	Hillier's court. Pile street.
50		Bennett, William	Tanner,	1 6	Southley's Paddock.
50		Brookman, Alice	Widow,	1 6	No. 15, Queen street, Pile hill.
65		Beer, Mary	Washerwoman,	1 6	Baptist Mills.
71		Brookman, Ann	Widow,	2 0	Patience entry, Redcliff-street.
66		Bain, Susanna	Widow,	2 0	Green's buildings.
77		Buson, Jonathan	Labourer,	1 6	Bishport.
		Blackmore's, George, 2 children		6 0	At William Lacey's, Waterloo square, Pile hill.
5—70		Bubb, Thomas and wife	Labourer,	4 0	No. 26, Colston street.
60		Babbidge, James	Labourer,	3 0	East street.
50	2	Bailey, Elizabeth	Widow,	3 0	Pump court, Limekiln lane.
45		Bzrge, Ann	Widow,	3 0	Bright bow.
7—70		Butler, John and wife	Labourer,	4 0	No. 4, ?outh place.
1—61		Brown, James and wife		5 0	At Mr. Birch's, Redcliff-hill.
	3	Blufod's, Mary Children		3 0	White house lane.
56		Board, William	Labourer,	3 0	Mr. Ball's, Bedminster parade.
9—55		Bucknell, James and wife	Baker,	2 0	No. 21, Great Ann street.
2—36		Biggs, John and wife		1 6	Still house lane.

Ages.	Children under 9 Years.	Names.	Description.	Per Week.	Residence.
		M		*s. d.*	
22—23	3	Merrick, John and wife	Shipwright,		New street, St. Philip's.
24	1	Morrish, Ann		3 0	No. 17, Bishop street, (husband absc...
37—39	2	Marshall, Joseph and wife	Cordwainer,	4 0	Castle green.
60—59		Morris, Thomas and wife	Painter and Glazier,	2 0	No. 6, Nelson's place, Redcliff parad[e]
71		Moxham, Sarah	Widow,	2 6	North street.
		Mills, Mary	Widow,	2 6	West street.
76		Martin, Jane	Cake-woman,	2 0	Bedminster place.
82		Mitchell, Hannah	Widow,	2 6	Bishport.
64		Marshall, Sophia	Widow,	2 6	Parson street.
66—58		Melhuish, George and wife	Labourer,	3 0	Paradise cottages.
41	1	Martin, Susanna	Widow,		At Mrs. Gage's Lawrence hill.
	1	Moxham's Elizabeth Child		1 6	
61		Moore, Maria		2 0	Bagg's court.
50		Morgan, Martha	Widow,	1 6	Green's buildings.
63—58		Mittan, James and wife	Labourer,	3 0	Cottage court, Jacob's wells.
37—47		Moore, William and wife	Smith,	2 6	Church street, Temple street.
57—70		Merrifield, Isaac and wife	Cordwainer,	3 0	North street.
45		Morris, Maria		3 0	Waters's place, Brown's row, (husban...
		N			
69—67		Nash, Samuel	Mason,	2 6	Marlborough street.
24		Norris, Mary	Widow,	2 0	No. 22, Brown's row.
43—45	2	Newbury Robert and wife	Smith,	5 0	Mill lane.
67		Newman, Rebecca	Widow,	1 6	Behind the Full Moon, Stoke's croft.
60	1	Narroway, Ruth	Widow,	1 0	No. 19, Philadelphia street.
46		Neale, Guy Margaret	Cripple,	2 0	No. 10, St. Philip's plain.
26	3	Nash, William,	Idiot,		No. 29, Temple street.
		Nash's, William Children		7 6	
18		Newport, Elizabeth		1 6	Tennis court.
16		Newport, Harriett		1 6	Boot lane.
20		Newport, William	Labourer,	1 6	Rope walk.
41—37	3	Neill, Joseph and wife		3 0	North street.

Part of the broadsheet that was attached to the church door in 1830, showing the names and occupations of those in Bedminster receiving poor relief under the Speenhamland system. The amount allocated had increased from £891 p.a. in 1803 to £3,488 in 1831, which required a huge increase in the poor rate levied on the property owners of the parish. Those relieved had come to expect the allowance as a right and the purpose of publishing this information was to shame those receiving it and brand them as beggars. It did not work.

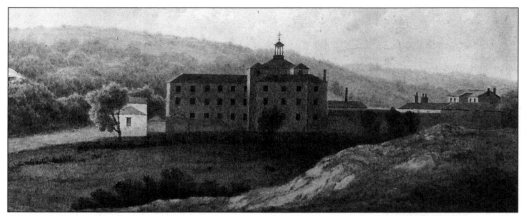

Water-colour of Bedminster Workhouse, *c.* 1839. The Poor Law Amendment Act of 1834 grouped Bedminster with 22 other parishes in the north-east corner of Somerset. At the geographical centre of the 'Union', Flax Bourton, the Union Workhouse was built (opened in 1838). Relief after 1834 was supposed only to be given to those who entered the workhouse. In practice, for much of the 'Hungry Forties' it was full to overflowing (500 inmates) and the authorities had to fall back on out-relief. Bedminster Workhouse was one of many designed by George Gilbert Scott, later celebrated for his Albert Memorial and St Pancras Station, London. [M11, M13, M14, M18].

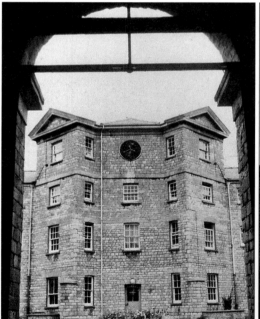
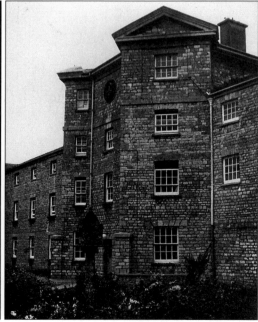

The central tower block from which, in the 1840s, William Allies, the workhouse master, and Eliza Plumley, the workhouse matron, supervised the dreary and soul-destroying duties of the paupers. Joseph Leech, writing of the Workhouse in 1848, recorded 'the same series of white-washed walls enclosing all' with no variety apart from the 'dull old and dirty faces' which greeted him on all sides. These photographs were taken *c.* 1974 when the building was a psychiatric hospital. It is now empty, though briefly considered in 1995-96 by the National Trust as a museum of poverty.

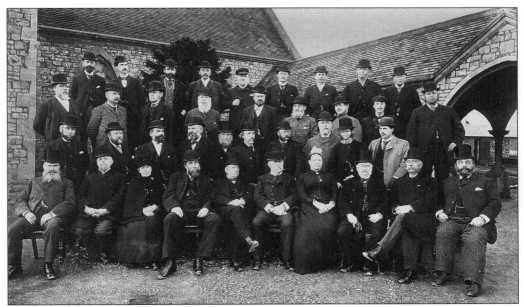

The Board of Guardians, *c*. 1880, posing for the official photograph in front of the chapel, added to the Workhouse as the gift of the Gibbs family of Tyntesfield Court. They were the cream of the lesser gentry, the prosperous middle class elected by the parishes of the Union to run the Workhouse on the most stringent lines possible. No doubt they did well out of it, monopolising contracts to supply the Workhouse with provisions: oakum to pick, stones to break and bones to crush. No wonder they look well-fed, self-important and affluent. We don't know their names – perhaps it is just as well.

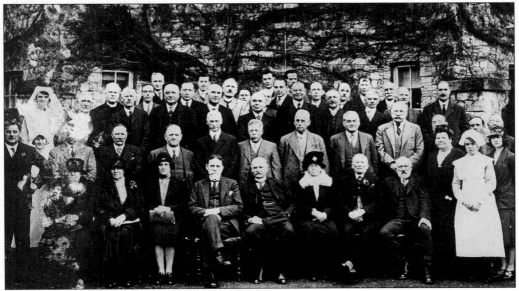

The Board of Guardians and staff in the 1920s. When Bedminster was finally brought into the city (1891), the Workhouse was renamed the Long Ashton Union. With old-age pensions and national insurance, workhouses became increasingly asylums for psychiatric cases. In 1930 the boards were dissolved and their duties transferred to local government.

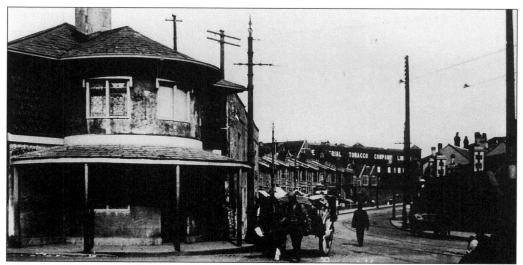

In 1748 the extension of the turnpike trusts produced a furious outburst from local farmers and other road users. Making common cause with Kingswood miners, they smashed the toll-gates at Ashton and burnt down the house of Mr Durbin who had been responsible for apprehending three ring leaders of earlier toll-gate riots. These men were later hanged on Bedminster Down for this outrage. Others perished of smallpox in the Bristol Bridewell and 18 men were removed to Wiltshire for trial as local juries were too sympathetic to the rioters. The southern approach to Bedminster is still called Ashton Gate, though the turnpike trusts were dissolved and the gates removed in 1868. The toll-house survives as part of a residential complex for senior citizens. [M6].

There were other toll-gates at the Sheene Road/West Street junction and on the Parson Street corner with Bedminster Down Road. The photograph dates from 1937 when the ticket office on the right still stood. It disappeared for road widening soon afterwards and the toll-house was needlessly demolished in 1965 for a temporary one-way traffic system.

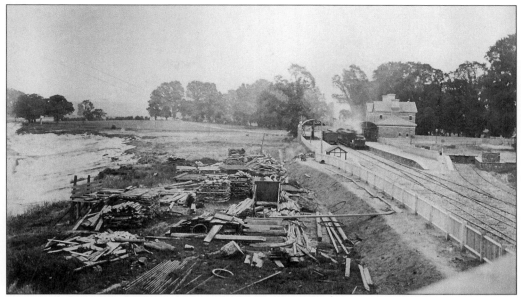

The first railway to reach Bedminster was the Bristol and Exeter Railway, projected in 1835 and finished in 1844. The Bristol-Portishead Pier branch line projected in 1849 (*see map on p. 6*) was finally opened in 1867, but not on the original route. The Clifton Bridge railway station was newly built in this photograph of 1869, and two broad-gauge trains are in the station. The railway was converted to standard gauge *c.* 1880, later amalgamated with the Great Western Railway (GWR) and finally closed in 1968. [M3, M4].

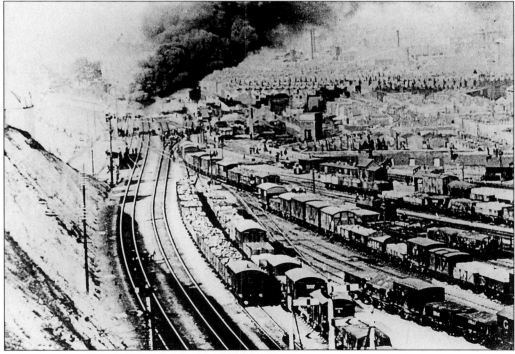

Railway siding below Pylle Hill, *c.* 1897, with smoke pouring from a fire.

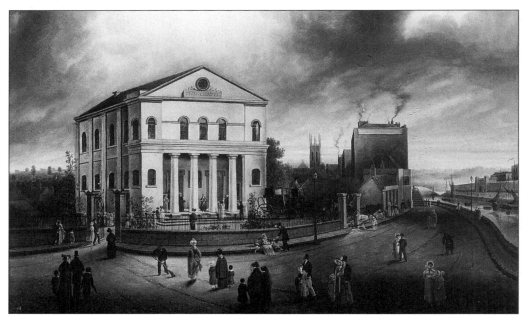

Above: the Church of the Vow, 1830. John Hare, a Somerset lad, came to Bristol in 1775 to make his fortune. He jumped down from the wagon that had given him a lift, climbed over a wall and fell asleep in an orchard. When he woke the next morning he thought he was in heaven; the sun was shining through cherry trees in full bloom. He made a vow that if he made his fortune he would buy that orchard and build a temple there. He became a successful oil-cloth manufacturer but did not forget his vow. Unfortunately, the orchard had disappeared following the construction of the New Cut but, finding a plot vacant nearby, he bought that,

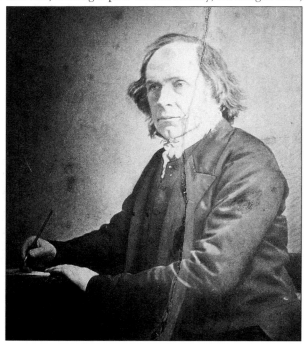

and Zion Church, Bedminster Bridge, was opened in 1830. The event was commemorated by Samuel Colman, the celebrated Bristol painter, who shows the fashionable families making their way to the church. The painting, minus frame and badly torn, was for many years used for a fire-screen in the vestry until rescued by the Malago Society. It now hangs, beautifully restored, in the City Art Gallery. [M5, M17].

Right: a portrait found in the vestry; it may be John Hare. In later years he was a capable elder and preacher in the church and on one celebrated occasion saved their funds from an unscrupulous secretary. Finding that he had embezzled the lot and fled to America on a paddle steamer, John Hare took a faster vessel and arrived first so the thief was arrested the moment he stepped ashore.

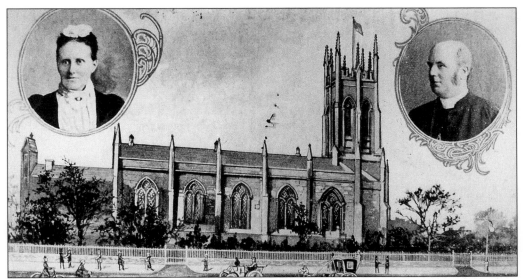

Concern that, with the rapid increase of the population, many souls would be lost to the dissenters led the Church Commissioners to authorise the building of St Paul's on Coronation Road as Bedminster's second church. It was designed by Charles Dyer (architect of the Victoria Rooms and Christ Church, Clifton) and was consecrated on 24 October 1831 by Dr Lew, Bishop of Bath and Wells. In common with other bishops, he had voted against the Reform Bill in parliament. His carriage was 'assailed by a few persons of the very lowest description with groans and hisses and as the carriage was driving off some dirt and stones were thrown at it'. Six days later the Bristol Riots broke out.

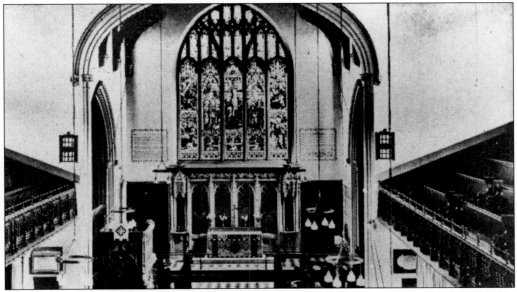

The first curate-in-charge was Revd William Lowder, who died in 1838 and was succeeded by that great churchman Revd H.G. Eland who later, as vicar of St John's, Bedminster (1852-83), undertook the notable rebuilding of that church. On 11 April 1941, St John's was lost in the blitz and was never rebuilt. St Paul's suffered extensive damage but was later restored in a very different style from the splendid Gothic interior seen here.

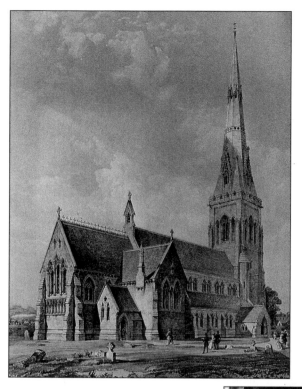

On the death of Revd Martin Whish (1852) his successor, Revd Henry George Eland, undertook the demolition of old St John's and its reconstruction in an elaborate early English style of Gothic. The design by John Norton, architect of the General Hospital, was famous for its slender arches, the transepts, an unusual feature in parish churches, and the richness of its decoration, especially the carved capitals. The lofty spire was never built. Note on the extreme left the Bristol and Exeter Railway whose track cut through the heart of Bedminster (1840-45).

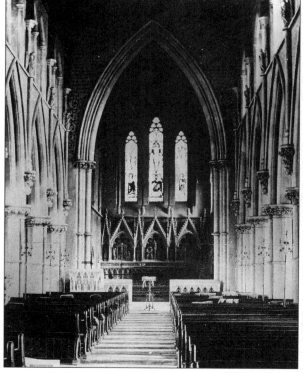

The new St John's was finished in 1854 but the consecration was delayed until 30 October 1855, due to a violent controversy over the new reredos. Revd Eland was a High churchman and profoundly influenced by the Oxford Movement. The carved reredos, presented by Mr Phippen of Church House, City Councillor, Mayor and much-loved benefactor of many Bedminster causes (*see p. 117*), was considered much too 'popish' by many Anglican clergy. The scenes represented the Adoration, Crucifixion and Ascension. The bishop twice requested Mr Phippen to withdraw the reredos but he declined. In the end Revd Eland was exhorted by the bishop to carry Phippen off by force 'just as two wagonettes of protesting clergymen, led by the Dean entered the gate'.

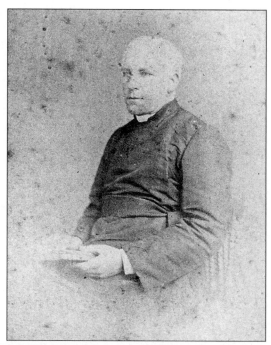

Revd Eland's zeal and High-Church principles made a lasting impression on St John's, Bedminster. He was the first vicar to have a surpliced choir; the National School and Society of the Sacred Mission came under the influence of his driving leadership and flourished. In 1852 the parishes of St Mary Redcliffe and St Thomas the Martyr, former daughter churches of St John's, were finally detached and St John's began its second great work of evangelism: St Peter's, Bishopsworth, (1843); St Raphael's (1858); St Luke's (1861); Holy Nativity, Knowle (1878); St Michael's, Windmill Hill (1886); St Francis, Ashton Gate (1887); St Dunstan's (1897); and St Aldhelm's, Chessels (1900).

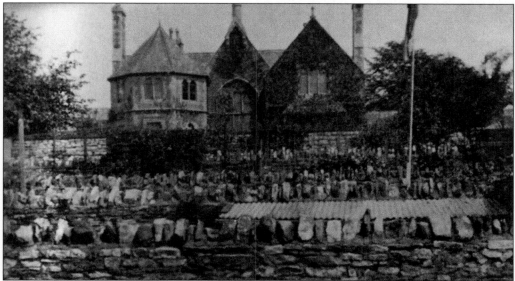

The separation of St Mary Redcliffe parish from St John's left Bedminster without a vicarage. From 1838 to 1857 Revd Eland lived at Southville Buildings, Coronation Road; then he went to Wellington Cottage. Finally money was donated – a sizeable proportion by Revd Eland himself, which he had received as compensation for injury in a railway accident – and an inspiring vicarage was built on the top of Greville Road just past the junction with Mount Pleasant Terrace. In fact it had a short life. It was occupied by Revd Eland, Revd Anstey (1883-88) and Revd Burder (1888-1902) but it was found to be much too big for Revd Baghot de la Bere (1902-1918), who was a bachelor. Therefore, he had two houses converted to his use in St John's Road, and the vicarage was demolished.

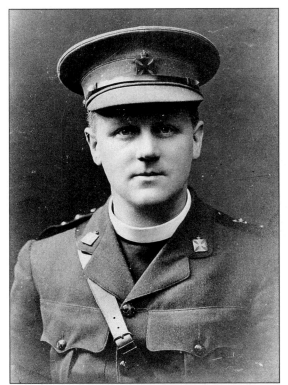

Revd John Baghot de la Bere, vicar of St John's, 1902-1919; a High-Church bachelor of colossal drive. His energy overflowed in all directions. He walked miles and miles, trailing his clerical friends over field and dale, arriving at local farms crowing like a cock and brimming over with hilarious anecdotes about his flock: one old chap suffered horribly from rheumatism and would always say, 'Ooh!! feels so bad vicar' – and here Baghot would give a vivid imitation of the old man's moans and groans – 'So one day I gave him a bottle of Hospital Bovril. "Try that," I said. A few days later he turned up, beaming all over his face; "I feel as right as rain," says he, "I rubbed in the whole lot".'

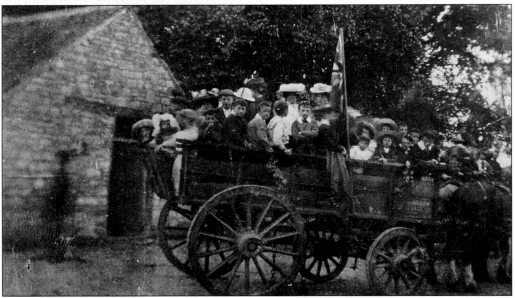

Baghot was sweet on Dorothy Hall of Filwood Farm and was a keen player at her tennis tournaments. Her father, Ben Hall, used to invite Baghot and as many as 1,000 Sunday school children to visit the farm in batches on Saturday afternoons. Ben Hall sent a farm wagon and, creaking and jolting up Novers Hill, the children and teachers came to tuck into the bread and jam, buns and tea on trestle-tables, followed by games in the field.

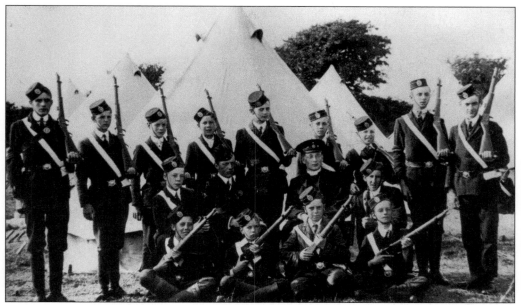

St John's Church Lads Brigade, *c.* 1912. They look very military – patriotism and godliness were one and the same thing to Baghot de la Bere. In 1917 he became Chaplain to HM Forces in France, and later in Egypt and India. After the war he found that his curate had made such a success of the job that he decided to move and returned to the family living at Prestbury, Gloucestershire.

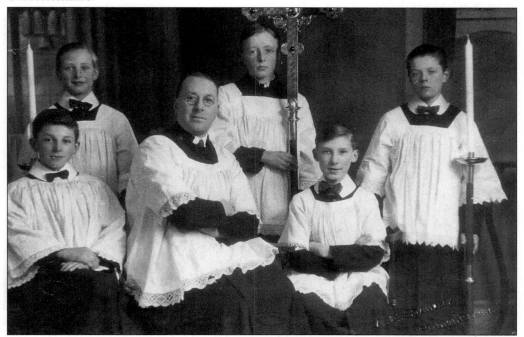

Servers at St John's, late 1920s. From left to right, back row: Jack Biggs, Ian Tandevin, Albert Monks. Front row: Ron Chappell, Spencer Owen, Maurice Knight. Ron Chappell's uncle, Harry Chappell, is in the top picture in the centre of the back row.

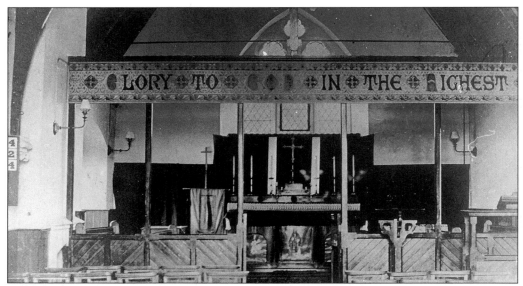

St Dunstan's began as a mission church at the foot of Bedminster Down Road in 1863. It was first under the responsibility of St Peter's, Bishopsworth, whose vicar, Revd Goldney Randall, had founded it. It was transferred to St Aldhem's in 1898 and finally became an independent parish in 1929. The parish was merged with St Aldhelm's, St Francis and St Paul's in a team ministry in 1975, and St Dunstan's, the smallest of the four, was closed for economic reasons in 1992. The building is now business premises.

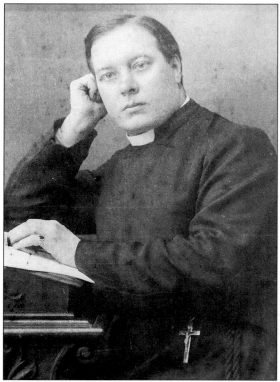

The ministry of Revd William John Rogers, 1910-1916, coincided with a period of spectacular growth at St Dunstan's. He was a man of boundless energy and enthusiasm; the number of Easter communicants rose from 97 in 1910 to 143 in 1911. Different groups like the Communicants Guild, the Guild of the Holy Redeemer, Bible classes, football and cricket teams catered for all ages and needs, and in 1912 an additional aisle was built increasing the seating capacity from 120 to 350. The same year, striking miners and railway workers ran riot, a signal-box was burnt down and the police turned water-cannon on the crowds who came to cheer the strikers on the railway bridge. The Salem Chapel in Trafalgar Terrace, opened in 1892, competed for the souls of the youthful, and Revd Rogers, reflecting the prejudice of the age, remained aloof and scornful. He became an Army chaplain in 1916 and after the First World War became vicar of St Aidan's. [M28].

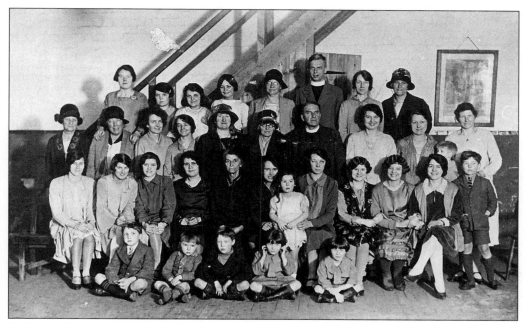

St Paul's Kindergarten, late 1920s. Revd Elwin, vicar of St Paul's, seated, and his curate, standing, pose with a group of mothers and teachers in their quaint schoolroom.

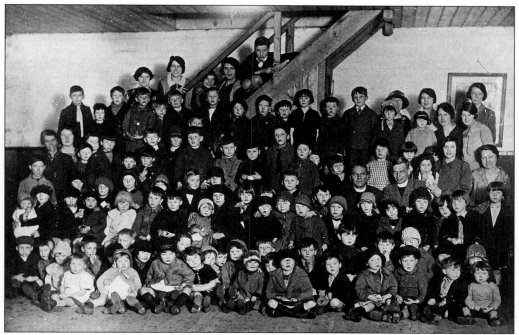

Children at St Paul's Kindergarten, none of whom we can identify. No doubt our readers will let us know in due course.

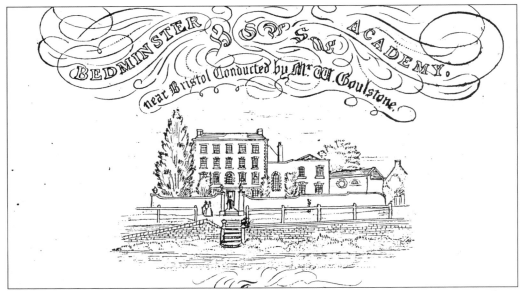

Bedminster Boys' Academy. This elegant vignette graced the prospectus issued by William Goulstone, senior churchwarden of St John's in 1840 and proprietor of Bedminster North Side Colliery. Bedminster House, a handsome Georgian building, stood at the junction of North Street and Hebron Road and was the home (1807-29) of Thomas Hasell, City Councillor, thrice Sheriff of Bristol and Mayor (1824-25). He attended the first public execution at the New Gaol on the New Cut, that of Thomas Howard, aged 18, who was hanged in 1821 for throwing a stone at his sweetheart from the effects of which she died. Mr Hasell handed the boy's body to Richard Smith, surgeon, for dissection, and Mr Smith had Howard's skin tanned and with it bound a book containing all the records of the murder, trial and execution. Mr Goulstone moved his Academy to Bedminster House in 1829 and carried on the school until 1848. He sold Bedminster House in the early 1860s and it was demolished in 1892. [M14].

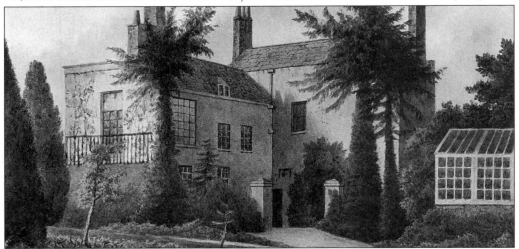

Dorset House, North Street, from a water-colour by William Curtis, c. 1819. This is the back of the house which evidently had a substantial garden. It was typical of the graceful eighteenth-century residences which graced Bedminster before industrialisation. Gaywood House tower block now stands on the site.

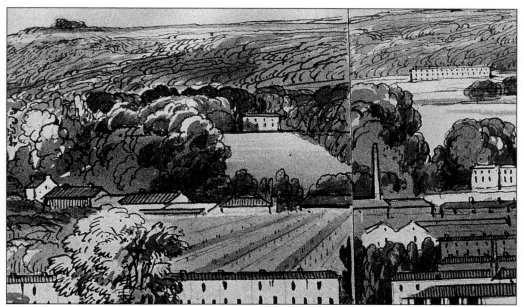

Rowbotham's panorama of Merrywood Hall, *c.* 1830, shows this fine house (centre) on elevated ground commanding extensive views of Brandon Hill and Clifton. It was the home of Thomas Llewellyn Vining, his wife and eleven children (from *c.* 1770-1801) after which it changed hands frequently. There is a tradition that the splendid greenhouses supplied pineapples to Princess Victoria and her mother, the Duchess of Kent, when they came to Clifton in 1830. In 1879, Mr W.A. Latham bought it, made it into a home again and restored it.

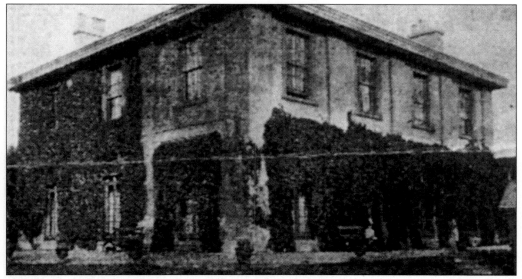

As it was in the time of Mr W.A. Latham. Clara Butt sang in the drawing room here at a concert in aid of the Hebron Methodist Chapel. Merrywood Hall, or an adjoining villa of the same name, is associated with the publisher, Mr Cottle, who patronised Coleridge and Wordsworth, and Mr Collard, the 'poet-butcher' of North Street. When Mr Latham died in 1909 the house was sold to the Corporation who demolished it and built Merrywood Elementary School on the site.

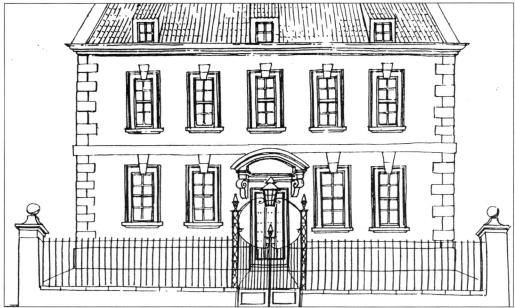

Hampton House, West Street, *c.* 1690. The building today is part of business premises and a mere shadow of its former glory. The surviving features point to its late seventeenth-century origins, and unverified oral tradition claims that it was the home of 'The Squire of Bedminster' and stood in a splendid formal garden with tree-lined walks. In the late nineteenth century Dr Neville and Dr Gow Cook ran their surgery in the fine panelled room to the left of the door. In 1921 the owner, Mr Rich, sold it to Dr Gow Cook's chauffeur, Harry Cross, a colourful figure who wore a ten-gallon hat. Harry Cross removed the wall, installed petrol pumps and ran a motor-car repair business there till 1939 when he sold to Ivor Ewins, Electrical Engineers. [M8].

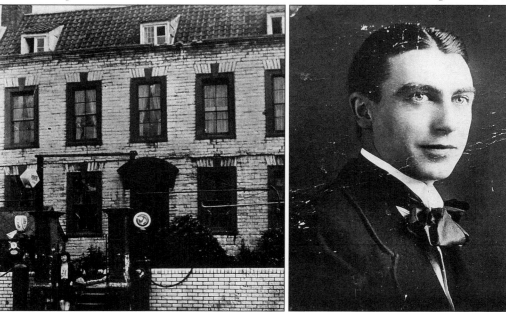

Left: the front of Hampton House with petrol pumps, *c.* 1937. *Right*: Harry Cross.

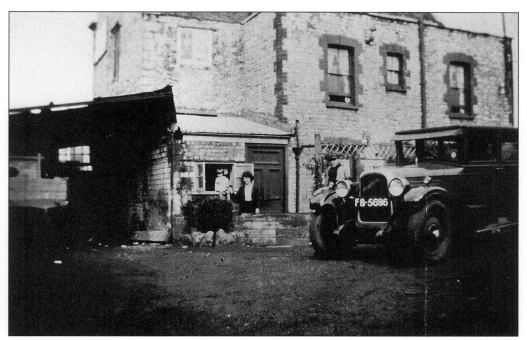

The rear quarters.

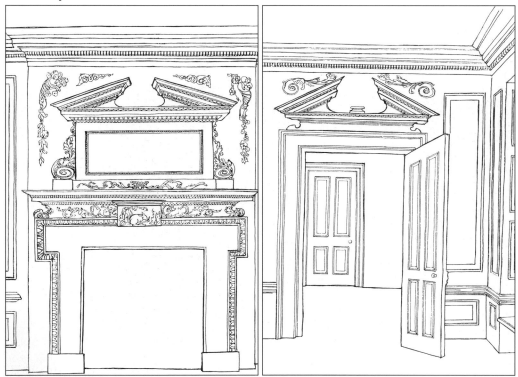

Left: the late seventeenth-century Spanish mahogany fireplace, drawn *c.* 1975. It is now boxed in. *Right*: door of the same room looking into the hall.

Lock's Mill, *c*. 1920. This splendid eighteenth-century house on the site of a mill several centuries older spanned the Malago in Parson Street at the foot of Novers Hill. After the Locks sold the house, it became the home of the Gee family; and, it is believed, was visited in his youth by Robert Southey who came to see his grandmother. It is hard to believe now that upstream from this house was a magnificent garden, well stocked with peacocks. [M11, M12, M13].

Mr Brightric Gee in the last years of the nineteenth century ran a snuff-mill and later a glue factory in the building next door, and a brickworks in Vale Lane where his name was picked out in black and white ceramic tiles on the chimney. His six workmen were summoned to the house at Christmas and given a gold sovereign from a bowl on the table.

Upstream, the Malago was dammed and the lake provided plentiful fishing and, when flooded over neighbouring meadows (now Somermead), a popular ice-rink for Bedminster folk. Brightric Gee was an eccentric figure. He passed himself off as the Lord of the Manor and owned the first motor car in Bedminster (c. 1902). Mr Gee allowed his splendid garden to be used for charity fêtes and so on, but these ceased when, provoked by the local youths, he lost his temper and threw one of them into the Malago. On hearing the boy's story, and knowing Mr Gee's fiery temper, several men came along and flung Mr Gee in. 'I saw Mr Gee climb out of the Malago, shake the water off like a terrier then whip off his coat and challenge the lot of them to fight him, one at a time,' said one of the guests.

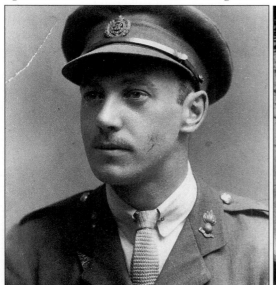

Left: the last occupant of Lock's Mills was Major Basil Long, a flamboyant officer, an ace air-pilot and horseman; his stunts for the film industry led to a first marriage with Mary Forbes, a film star who featured in *Anna Karenina* with Greta Garbo. *Right*: in the 1930s Lock's Mills became a mecca for glamorous people. The ladies are the second Mrs Long and his mistress. In one of the first air-raids of the Second World War (24 November 1940) Lock's Mill received a direct hit and was destroyed. Major Long, then Commander in Chief of the Observer Corps, was in it at the time. He escaped, salvaging the bell from the wrecked bell-turret, but succumbed to the hard stuff in April 1978.

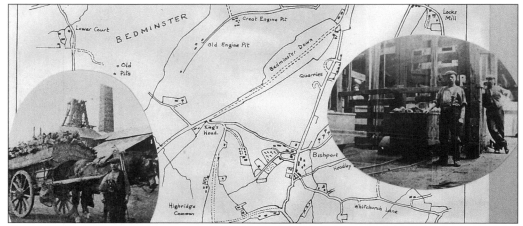

Open-cast coal-mining had taken place in Ashton Vale since the seventeenth century. The first shaft was sunk at South Liberty Lane *c*. 1745 by Henry Bennett, a mining surveyor brought from Kingswood by Sir Jarrit Smyth. Extensive coal seams were discovered just south of Long Ashton, near the surface, along a line running north-east to south-west, and falling away towards the south-east. By the 1820s over a dozen coal-pits were being worked in sight of Ashton Court and the Smyth family began to draw a considerable income in royalties from the many small operators who worked them. [M,1, M3, M4, M10, M26, M31].

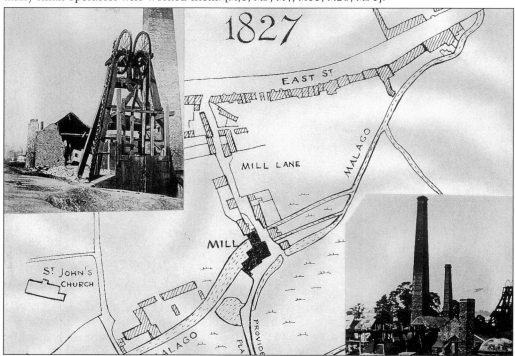

The increasing demand of industry and steam transport called for greater efficiency, and by the 1880s the smaller companies had amalgamated into four larger ones: Ashton Vale Colliery (now the site of Strachan and Henshaw); South Liberty Lane; the Argus Pit, West Street – alternatively called the Red Cow or Malago Pit (later the site of the Colodense factory); and Dean Lane Pit (now Dame Emily playground).

The Bedminster and Ashton Vale coalfields transformed Bedminster from being a decayed market town in the eighteenth century to a high-density industrial suburb of Bristol. A hundred years later, between 1850 and 1880, 40-50 per cent of the adult male population were miners. A comparison of the two maps on these pages shows the transformation in only fourteen years. Considerable numbers of people migrated to Bedminster from North Somerset and South Wales to work in the coal-pits and supporting occupations. The railway revolution cut a great swathe through hills and fields (the Bristol and Exeter Railway was opened to Weston in 1841). The proximity of coal and water from the Malago attracted other industries especially smelting, tanneries and engineering work.

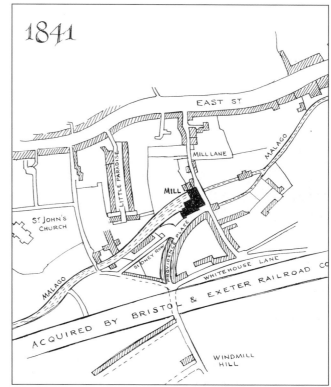

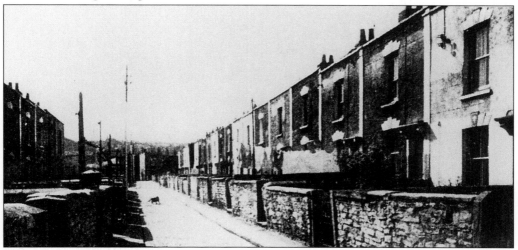

Little Paradise, built c. 1840, was typical of the new terraces constructed to accommodate mining families. This street, only wide enough for a cart and horse, always prided itself on the neat front gardens and took its name from an orchard known as a 'Paradise' that previously occupied the site. About the same time, the first miners' dwellings appeared in Dean Street, Providence Place, West Street and Whitehouse Lane. These dwellings had no drainage or water supply. Over-crowding, the congestion of houses and workshops and decline in living standards had by 1850 produced a major public-health problem. In the cholera epidemic of 1849, Bedminster suffered more fatalities than any other part of Bristol.

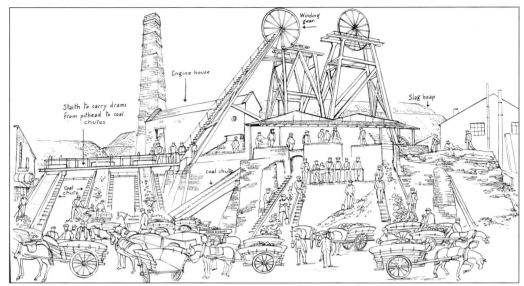

Drawing made from the remarkable photograph of Dean Lane Colliery, *c*. 1870. This was the largest colliery and the shaft descended to over 1,000 feet, and it employed at this time over 400 miners. It was quite normal to see as many as fifty hauliers with their carts waiting all night for the coal to come down the chutes. Vic Hill, the son of a haulier on Bedminster Down, remembered being sent straight to school from delivering coal, with coal-dust still in his finger nails.

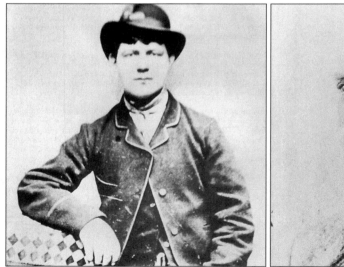
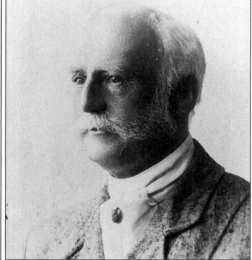

Left: Isaac Cleverley. He was killed in Dean Lane Colliery, aged 39, in 1906 when drams broke loose and crushed him. Four weeks later the colliery closed. Accidents, mostly from rock falls, were common. At Dean Lane Pit nine were killed in 1886; ten in the Argus Pit in 1891. If the mining companies could prove non-liability there was no compensation for families. *Right*: John Ryan Bennett, manager of Dean Lane Colliery, 1854. The Bennetts have a long association with the coal industry in Bedminster, and even earlier in Kingswood. John Ryan was descended from Henry Bennett who first procured the South Liberty Lane Colliery for Sir Jarrit Smith in the 1740s. They continued to have a major interest in the industry until it closed down.

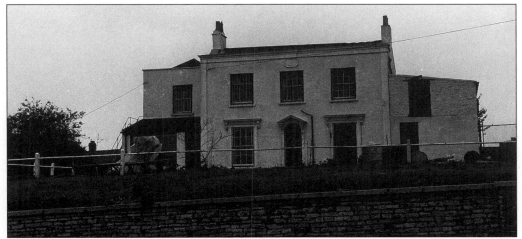

Rock Cottage, built 1820. It overlooked the junction of West Street and Parson Street and was the home of the Bennett family for many years. Originally it had outbuildings and extensive grounds. Now refurbished, with flanking wings, it is smart business premises.

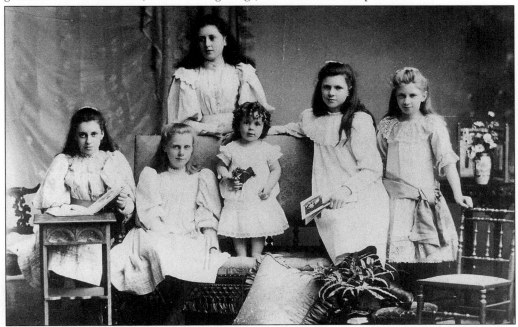

A delightful photograph of Mr Bennett's children. From left to right, his daughters Constance, Margery, Rachel, Dorothy and Evelyn and, in the centre, his son, Henry. The story is told how one afternoon the baby was tiresome, so his nursemaid took him down the orchard at the back of the house so that his sisters were not disturbed during their lessons with the governess. At the bottom of the orchard was a well. The nursemaid sat on the parapet with Henry on her lap; but the parapet was crumbling and collapsed and both nursemaid and baby fell down the well. Half-way down a rusty pipe impaled her side and checked her fall but her cries for help were not heard for over an hour. During the whole time she did not let go of Henry. Both were rescued and recovered. The housemaid later married the gardener, but, sad to say, Henry was killed in the First World War.

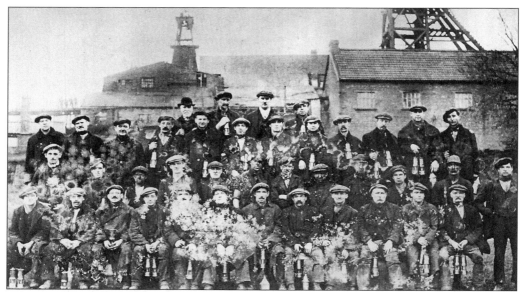

Miners at South Liberty Lane Colliery, *c.* 1923. This was the oldest of the pits: the first to open and the last to close. From the pit-bottom, underground ways extended to points below Dundry Church in one direction and Temple Meads station in the other. Although 800 feet below the surface, miners could tell the time from the rumbling of trains above them. From the Bedminster Great Vein, the thickest of the coal seams (4ft), an enormous volume of coal was extracted; the ground surface has settled by about 18ft in the last 150 years. Subsidence in older buildings is common in Bedminster.

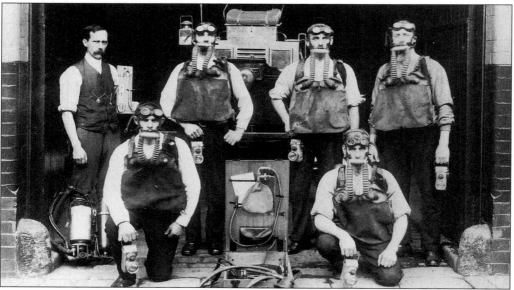

The Rescue Association at South Liberty Pit, *c.* 1920. From left to right: J.S. Moore, Josiah Smith, W. Cook, S. Wherlock, A. Snooks, Jasper Langwood. The Bedminster pits were considered non-fiery, but 'after-damp' was a problem. It descended to the lower pockets of the mine and could suffocate miners; hence the breathing apparatus and appliances to resuscitate miners. Most casualties, however, were caused by rock falls.

South Liberty Lane Colliery, *c.* 1910. It has been calculated that the Smyths received 8*d* in royalties for every ton mined at the colliery. When coal ceased to be mined in 1925, the colliery became a brickworks. Now it is part of the Ashton Vale business estate and only the miners' foot bridge over the railway – the last part of their daily trek from as far afield as Bishopsworth, Dundry and Whitchurch – survives.

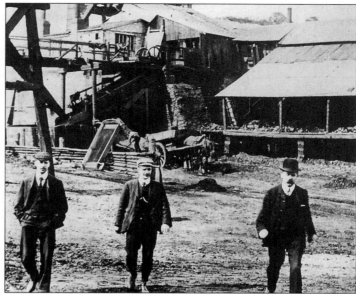

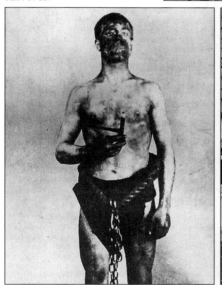

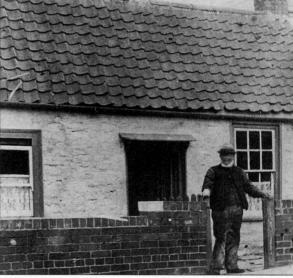

Left: Henry Godfrey, miner in South Liberty Pit, *c.* 1900. With candle in hand, or more often fixed to his helmet, the 'tugger' advanced on hands and knees with 'guss and crook', a horsehair belt with a chain which passed between the legs and was attached to a 'butt', a kind of sledge carrying 3-4 cwt of coal. The 'guss and crook' were painful to wear and sometimes rubbed the miners' bodies blood-raw below the belt. They used to rub urine into their sores. Henry Godfrey ended his days as landlord of the New Inn, Bedminster Down. *Right*: miners' cottages at Hills Barton, Bedminster Down, *c.* 1910. On the right is Joe Wring, one of the toughest and roughest of the South Liberty Lane miners. He had a shovel specially made that could heave nearly a hundredweight at a time. Once someone bet him £5 he couldn't lift a miner called Colin Marshall, who weighed 14 stone, on his shovel. Joe put Marshall on his shovel and chucked him in the trolley. Others thought nothing of trundling a wheelbarrow full of bricks to Weston-super-Mare and back for a 5/- wager. [M5, M9].

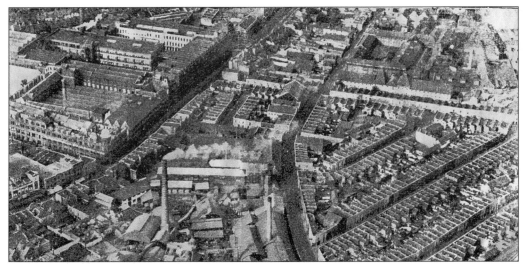

Capper Pass first acquired land north of Mill Lane (bottom left) in the 1840s when the availability of plentiful water from the Malago provided the cooling for the smelting of lead, tin and solder from the slag from which zinc had already been extracted. He lived in Richmond Terrace (now Cotswold Road), the first street constructed on Windmill Hill. By 1938, the year of this aerial photograph, the smelting works almost filled the rectangle bordered by East Street (to the left), Clarke Street (centre), Philip Street (top) and Mill Lane and Paul Street (bottom), where the entrance was situated. The tightly-packed dwellings in the triangle to the right were built in the 1860s by Philip Percy Doveton Clarke. [M30].

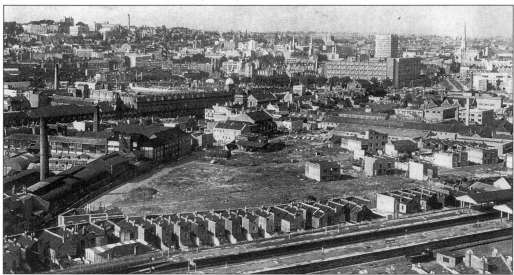

The same works in 1966. Capper Pass smelting works still remains (extreme left) but was shortly to be transferred to Melton on the River Humber and the site cleared to make Dalby Avenue and the Bedminster car-park. Also shortly to be demolished was the Western Tannery (the second tall chimney from left). Almost all the worn-out terraced dwellings of Clarke, Doveton, Percy and Philip streets have been cleared, leaving only the side of Whitehouse Lane bordering the railway embankment. In the 1970s this site became a disgraceful wasteland of weeds and unofficial tips until acquired and transformed by Bristol's first City Farm in 1976.

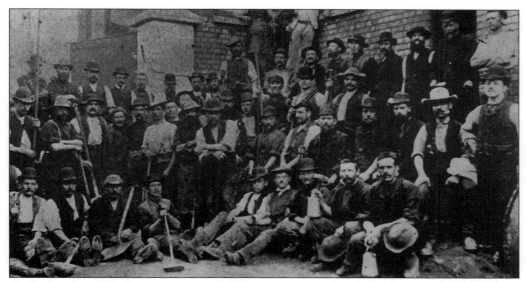

At the height of the firm's success, 150-180 men were employed. Here is one shift off duty *c.* 1887. Alfred Capper Pass, son of the founder, purchased most of Windmill Hill and built Vivian Street, Fraser Street, Algiers Street and Gwilliam Street to house his workforce (Fraser was his mother's maiden name). He also gave land for St Michael's Church in 1886, endowed it generously and rebuilt it in 1929 when it was destroyed by arson. Work at Capper Pass was exhausting and dangerous. Men dripping with sweat staggered off each shift and Mr Giles of the Spotted Cow in Providence Place already had scores of beers decanted to revive them before they went home.

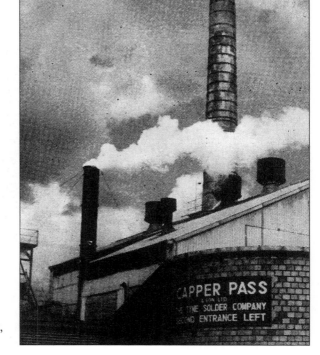

Entrance to Capper Pass in Mill Lane, 1960. Its tall chimney stacks dominated the area and the steam-hammer shattered the silence by day and night. Local people were so conditioned to it that it only disturbed them when, unaccountably, the steam-hammer fell silent.

43

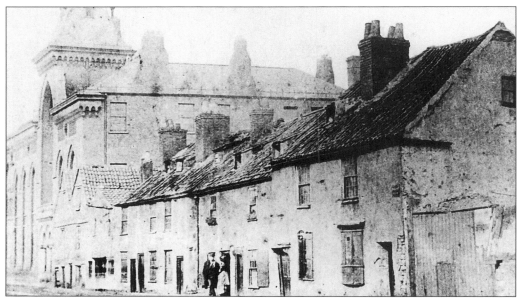

W.D. and H.O. Wills moved their tobacco business from Redcliffe to their No. 1 factory, East Street, in 1886. The elaborate neo-Gothic building was designed by Frank Wills and constructed on the site of the former St Catherine's Hospital (*see p. 10*). Although the tobacco complex was vastly enlarged in the period 1908-1940, this original building together with the Imperial Tobacco offices in Lombard Street is the only one to have survived the clearing of the site for the ASDA supermarket and car-park, 1988. The insanitary Brightbow cottages alongside, periodically flooded by the Malago which passed under East Street at this point, were condemned and demolished following an outbreak of smallpox there in 1890. [M20].

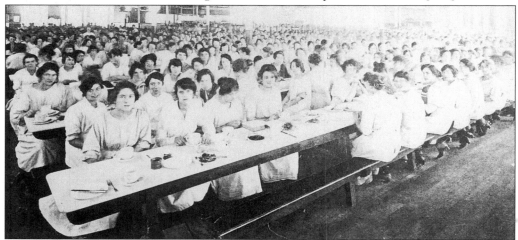

The canteen, *c.* 1930. On the opening of the first East Street factory in March 1886, high tea and entertainment were provided for 900 workers and their families in the cigar room. Mr R. Ward's band played a selection and Mr G.A. Webb's cornet solo *The Lost Chord* received an ovation and loud calls for an encore. In a blaze of electric light – the first used in business premises – members of the Wills family made speeches underlining the supreme importance of good relations between bosses and work force, a notable feature of the tobacco industry for over one hundred years.

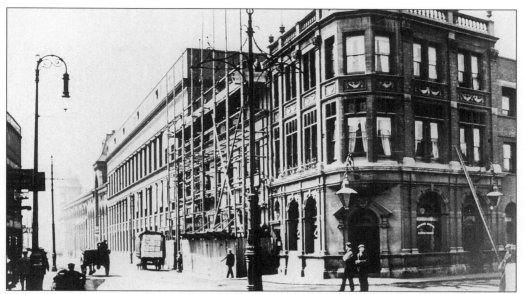

The East Street frontage was enormously extended in 1902; the grandiose Imperial Tobacco wing was built at the Lombard Street end in 1908, and in 1911 the remaining Brightbow Cottages and the Bedminster Hotel, shown here, were purchased, demolished and the tobacco warehouses extended to Regent Street. By 1940 the complex included most of what is now the ASDA supermarket and car-park. No. 2 Factory, No. 3 Factory and No. 4 Factory, all in terracotta brick, appeared on the North Street-Raleigh Road in site 1904-06 and most of these have in recent years been replaced by a small supermarket and car-park, the HQ of St John Ambulance Brigade and a large nursing home.

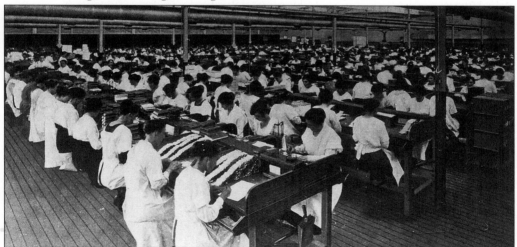

The work-floor, showing working conditions in 1930. W.D. & H.O. Wills carefully selected their employees for their moral rectitude and personal appearances and expected scrupulously high standards. A job with Wills' was regarded with some prestige, and the members of this miniature empire led charmed lives with medical and dental care, paid holidays and a wide range of social and recreational activities. The hilarious experiences of a new machine operator, May King, in the 1920s appear in the first number of *Remember Bedminster* in an article called 'Thanks to the Soul of Lillith'.

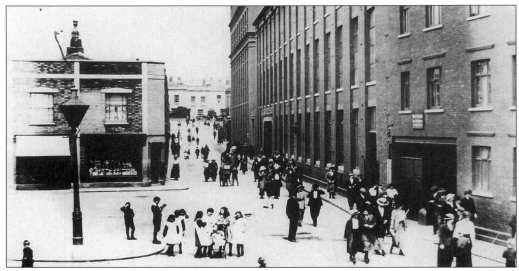

The immense W.D. & H.O. Wills' tobacco complex cast its shadow both metaphorically and physically over the tightly-packed streets of little homes. Several generations of Bedminster folk grew up within its all-pervading and benevolent patronage. Loyal employees had their portraits painted, received advantageous training schemes and long-service benefits; and though the Wills' empire has long since passed away – removed to Hartcliffe in the 1970s and progressively run down – it is still remembered with pride and affection.

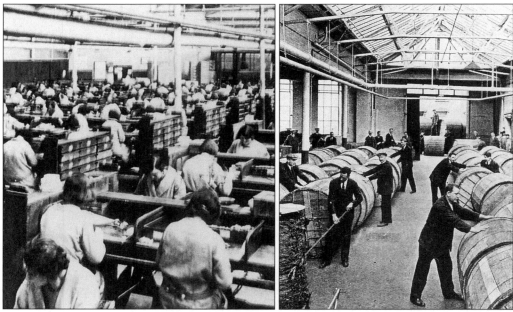

Left: rolling cigarettes by hand. Henry 'Harry' Herbert Wills, the brilliant engineer in the firm, introduced Bonsack cigarette machines in 1883, invented air-tight cases for exporting cigarettes in 1887 and 'handy-packer' machines in 1902. *Right*: unloading hogsheads. Cigarette smoking only became popular after the Crimean War (1854-56). Wills' first popular brand was the 'Bristol' cigarette (1871), followed by 'Passing Cloud' and 'Three Castles' (1877). The longest-reigning favourite was Frederick Wills' 'Wild Woodbines' launched in 1888.

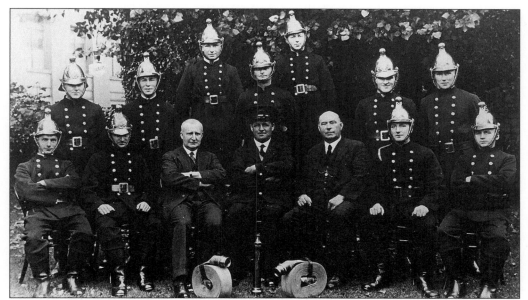

Wills' firemen at No. 4 Factory which was taken over by Wills' from its previous operators, the British American Tobacco Co., at the end of the First World War. The civilian in plain clothes (third from left) is M. Crocker, manager, and (third from right) is Mr Jarman, engineer.

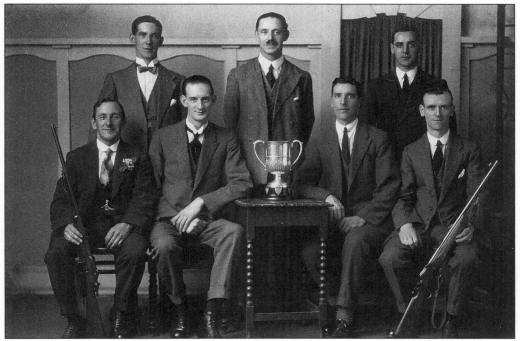

No. 9 Team, No. 4 Factory, 1924, the previous year's champions of the Departmental Rifle League. Top row: A. Hassell, W. Harris. T. Berry. Bottom row: F. Smith, G. Westaway, S. Bancroft.

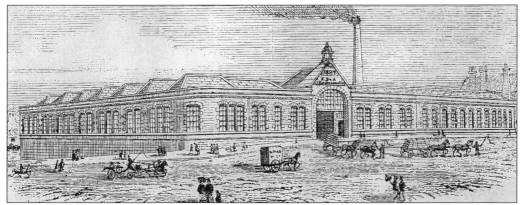

E.S. & A. Robinson first extended their paper-bag and printing business to Bedminster in 1887 where their first terracotta brick factory was constructed on the corner of East Street and St John's Road. This was a single-storied building, but rapid expansion caused a serious shortage of space in 1902. The entire roof, sky-lights and all, was jacked up and two extra floors inserted below. This is now the premises of Cameron Balloons. [M21, M22, M23, M32].

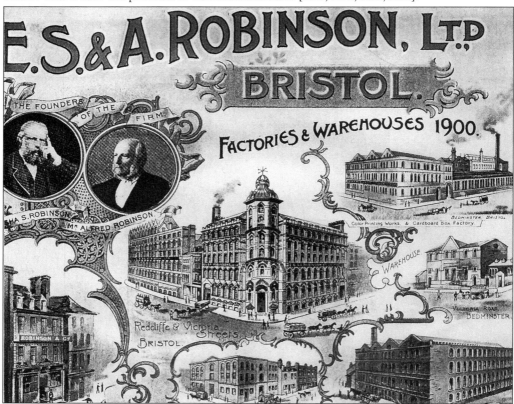

In 1897, a second much larger extension building appeared on the congested site between the Bell Inn, East Street, and St John's Church. This building, now (1997) unoccupied, still dominates the Bedminster skyline and cuts off the ancient church from the community. In 1912 Robinsons acquired the site of the Malago Coal Pit and built their third Bedminster factory in which they developed the Colodense printing process introduced from the USA.

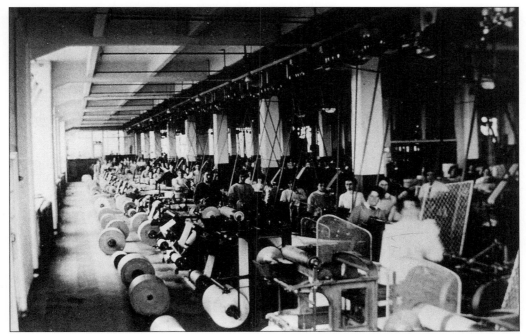

Interior view of the Malago factory in the 1920s. The drive for the bag-making and printing machinery was provided by three old Model T Fords, with their tyres and bodywork removed, the engines clamped to the floor, belting attached to the shafts, exhausts extended to the window, and hoses run from a hand-washing trough to prevent overheating. This improvisation was the invention of Tom Carpenter, the company's chauffeur, 1923.

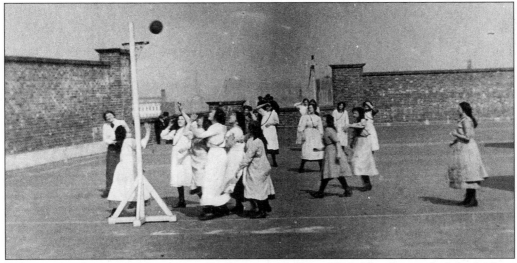

Robinsons' girls in aprons and overalls playing netball, c. 1919. The flat roof of the Malago Factory was used as a recreation area before Robinsons' bought land for the present sports complex in St John's Lane. The Robinson family established a tradition for organised sports, and inter-factory competitions in tennis, cricket and netball were the order of the day. Whist-drives, Christmas parties, concerts and rambles provided a limitless variety of recreations for Robinsons' employees.

In the 1890s the congested space between York Road on the New Cut and the Bristol and Exeter Railway was packed with inferior housing: Spring Street, Princess Street, Whitehouse Street, St Luke's Road, Weare Street and Mead Street. By the 1880s the area, now called St Luke's parish, East Bedminster, became notorious for its poverty. Revd David Doudney, fresh from the Irish famine, and after 1859 the celebrated vicar of St Luke's Church (shown here), tackled the problem head on.

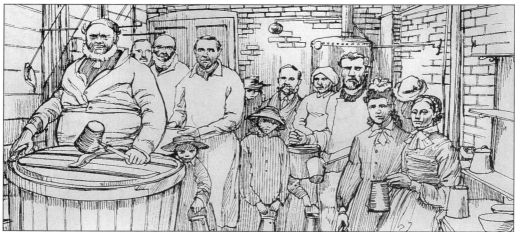

In a building which stands in William Street, Dr Doudney established c. 1874 his famous soup kitchen which twice a week provided soup dinners for 150 poor children from the Ragged School. From a newspaper report c. 1883: 'During the past week Dr Doudney has had his soup kitchen thronged with men out of work, and even in the day time ... hungry men have followed the Doctor down to his soup kitchen and from 50 to 80 at a time have licked the basins of soup at the adjoining Ragged School. Speaking of the appearance of the school on Friday morning, when it was filled with Ragged School children and 78 men out of work who dropped in for a basin of soup and thick slices of bread, the Doctor says "I don't think I have ever witnessed a more touching scene, even taking into account the famine scenes in Ireland".'

St Luke's Day School in Spring Street had 976 children on its books in 1883; 150 attended the Ragged School and 600 the Sunday school. To meet the needs of the army of poor children, Dr Doudney organised a mission in William Street, mothers' meetings, district visitors, and a 'printing nursery' which poured out thousands of pamphlets, leaflets and hymns to uplift the minds of his numerous parishioners. He also found time to keep a diary, and his autobiography, full of spiritual insight as well as social history, was published under the title *The Credentials, Call and Claims of the Christian Ministry*. He retired, much lamented, in 1891.

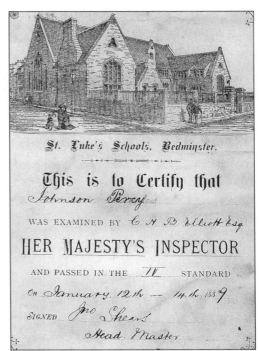

St. Luke's Schools, Bedminster.

This is to Certify that

Johnson Percy

WAS EXAMINED BY *C H B Elliott Esq*

HER MAJESTY'S INSPECTOR

AND PASSED IN THE *IV* STANDARD

On January 12th — 14th 1889

SIGNED *Jno Shears*

Head Master

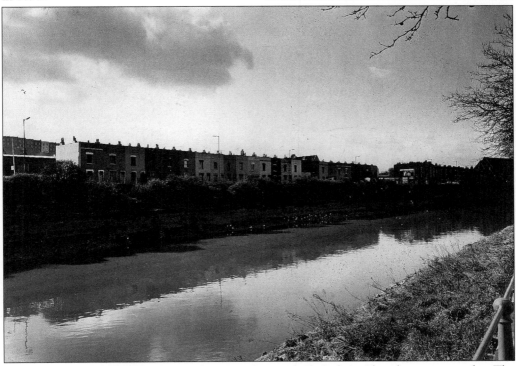

Poor houses in York Road, lining the New Cut with St Luke's Church extreme right. The church was closed and demolished in the 1960s and the entire district is now an industrial estate.

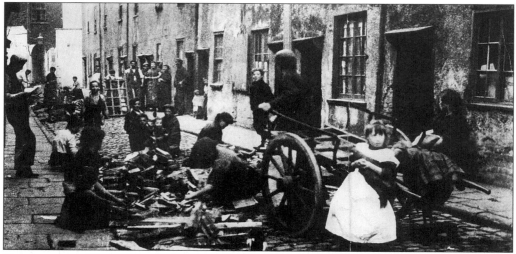

The first part of Bedminster to be intensively industrialised was the block between Bedminster Causeway (Parade) and Whitehouse Street. Alongside tanneries and paint works, courts, alleys and tenements swarmed with humanity. Joseph Leech in the 1840s likened them to 'the plagues of Egypt'. In Bedminster Place, popularly known as Woodchopper's Court, a number of families, including several generations of Stenners, tramped the streets collecting orange boxes and scraps from saw-mills; and the cobbled stones, summer and winter, resounded with the noise of their chopping as bundles of faggots were tied up (nine to a bundle and the tenth driven in to tighten the string) and then sold from a cart at a penny a bundle for firewood. This photograph dates from *c.* 1902. Today only the archway and kerb stone remain. [M25, M26].

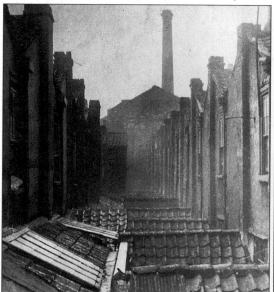
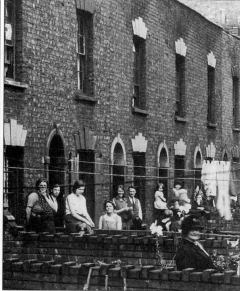

Left: Back of houses in Hope Square and Weare's Buildings. Lack of space, lack of air and the nauseous waste products of tanneries and industrial smelting washed down by the Malago that flowed underneath made these dwellings the most unhealthy district in Bristol. They were condemned and demolished in 1933. *Right*: Weare's Buildings alongside the glue factory that processed the waste products of the tanneries.

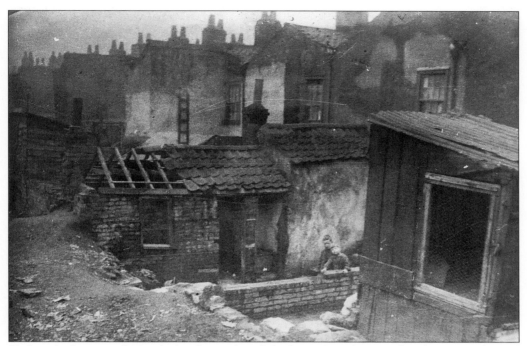

Backyards, Sargeant Street, before being demolished c. 1920. The area then became industrial premises. [M25].

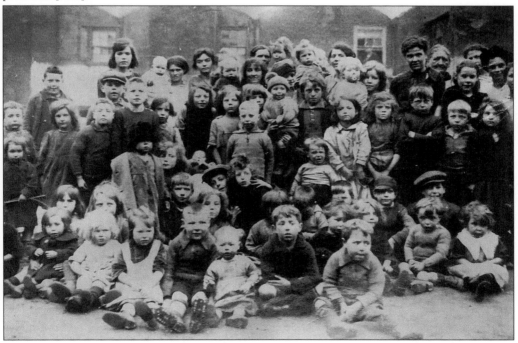

The children of Water's Place in the 1930s. Most of these attended St Luke's School or the Board School on Bedminster Bridge, popularly known as Boot Lane. The little boy, third from left, shows the metal-studded soles of his charity boots.

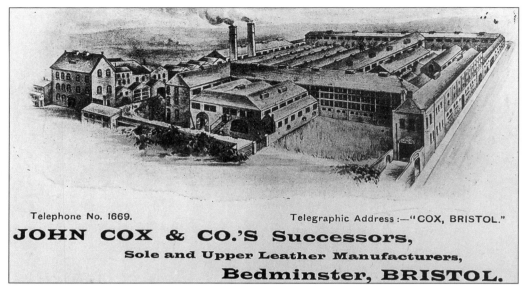

Telephone No. 1669. Telegraphic Address :—"COX, BRISTOL."

JOHN COX & CO.'S Successors,
Sole and Upper Leather Manufacturers,
Bedminster, BRISTOL.

The plentiful supply of water from the Malago attracted tanneries to Bedminster from an early date. There were at least eight of them in the nineteenth century, including four major ones. The noxious waste and distinctive smell was a constant threat to public health in the high-density back streets of lower Bedminster. One of the largest was Cox's Tannery, which imported goat skins from India and Nigeria for shoe uppers and cow-hides from Argentina and Uruguay for soles. Most of the finished leather was sent to Kingswood.

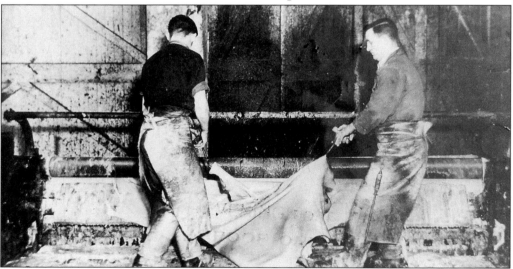

'Fleshing a hide' at Cox's Tannery. The offal of hair, ears and fleshy linings of hides were sent to Bristol Manufacturers, York Road, to produce gelatine, glue, grease and purified cow hair. (Ware's Tannery on Clifthouse Road still carries on the same manufacturing process). The gelatine went to Ilford and Kodak for film making, the grease to soap-makers, and the hair went to carpet-makers. Bristol Manufacturers occupied the site of the former Bedminster Tannery which went bust c. 1907 when the manager, William Percy, squandered its assets. They say he used to light a cigar with a hundred pound note; on that occasion 400 employees were turned out with no social security.

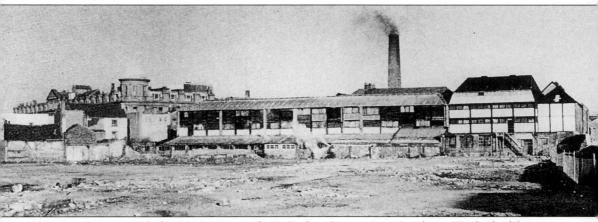

Western Tannery, Clarke Street, exposed 1967 after Capper Pass Smelting Works had been cleared for making Dalby Avenue. The tannery disappeared soon after.

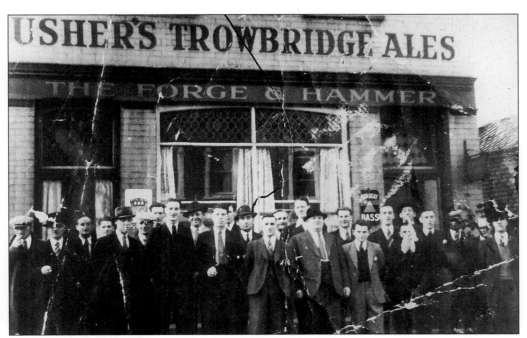

Cox's Tannery darts outing at the Forge and Hammer, Redfield.

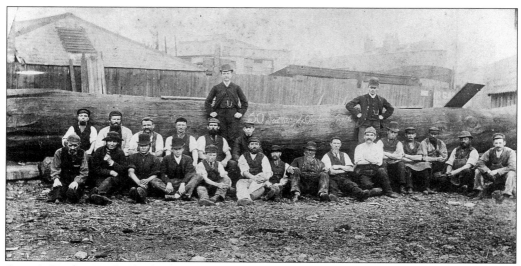

Organ's Timber Yard, Charlotte Street, 1890s. The area was subsequently absorbed by the W.D. & H.O. Wills complex. The proprietor's sons, Ernest (left) and Edwin (right) are standing wearing bowler hats with the men seated in caps and neckerchiefs.

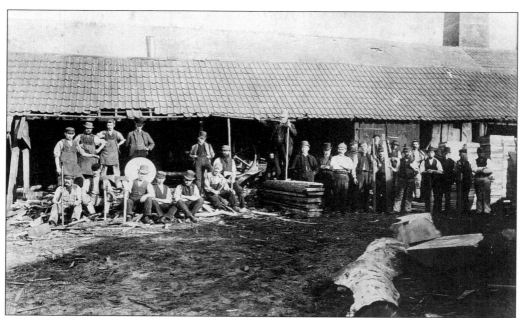

A more informal group with Mr Edwin Organ himself standing on a stack of sawn timber. Ship-building still required quantities of well-seasoned wood well into the twentieth century. In the Edwardian age the timber-yard was a popular fair ground site.

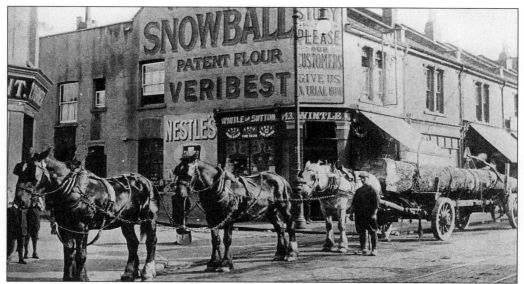

Shire-horse team and timber wagon, West Street, about to turn into Toogood's Timber yard, Ireton Road. This is one of the three teams of shire-horses managed by the Hasell family in Parson Street. E.C. Hasell said, 'Shires were not guided by reins; they were not needed as the gentle giants were raised to obey words of command and were addressed by name'. In the background is Wintle's Store on the corner of Bartlett Street. [M11].

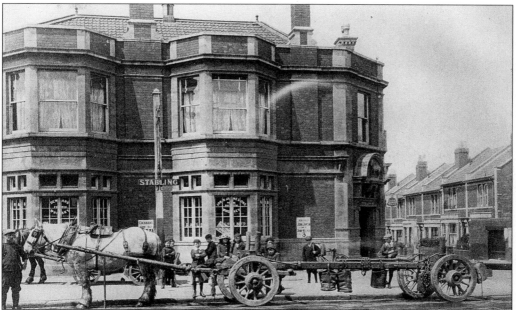

Timber wagon outside the White Horse pub in West Street, c. 1910. To see this team doubled up to a loaded wagon taking an incline at speed with the driver shouting commands was a familiar but unforgettable sight of those times. The White Horse, built 1900, was 'a spit-and-sawdust pub but my father changed it,' said Bill Garland, publican for many years. 'When you opened the door, sawdust blew all over the place. Those were the days when a tot of whisky cost 6½d and a bottle of Scotch 12s 6d. We used to sell 'bottle noggins' – about one-fifth of a bottle.'

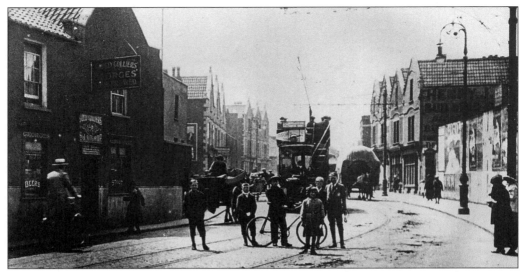

Looking up West Street, c. 1925. It was then quite a smart and prosperous area with attractive shop-fronts and imposing façades. Elaborate street lamps and tram cables, festooned from decorative brackets, were complemented by colourful billboards. Traffic was still mostly horse-drawn; the cobbled road surface and tram-lines are well sprinkled with droppings. John Bishop was landlord of the Jolly Colliers. Most of the gabled houses on the left were removed to improve the approach to Colodense in the 1960s; the remainder are scheduled for demolition (1997).

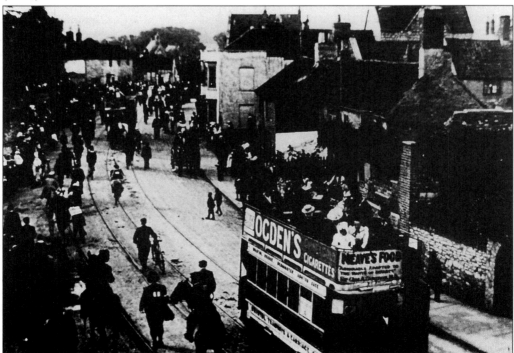

North Street in 1898. Barnum and Bailey's Circus is making its way to the fairground in the green fields that still bordered the left-hand side of the roadway.

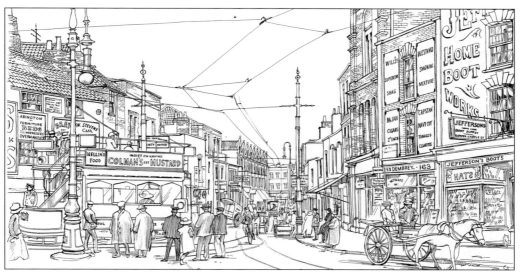

Intersection of East Street and Cannon Street, *c*. 1913. The drawing, based on old photographs, conveys something of the visual impact of Edwardian Bedminster. Scarcely a square inch was spared with a colourful assault on the senses from scores of small vibrant businesses, street vendors and costermongers, the noise of tram wheels shrieking in the grooves (especially on corners); the clopping of draymen's carts and horses' hooves on the cobbles; the cries of drovers, hauliers and salesmen; and the diversity of dress and appearance of miners, tradesmen, cockle-women and street entertainers can only be paralleled nowadays in places like Kowloon and Karachi. [*For Bedminster shops*, M13, M14, M17, M21, M23, M31, M32, M34, M35].

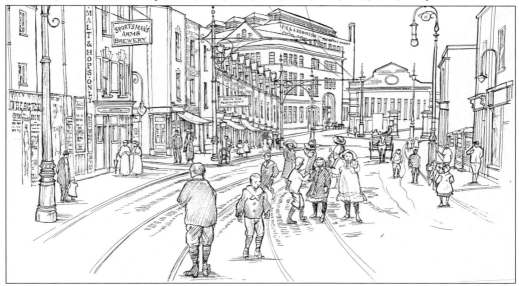

West Street intersection with East Street and Sheene Road, *c*. 1910. At least twelve children play safely in the street. There are many small eating-houses, cheap lodgings, and pubs (the Sportsman's Arms is now the Black Cat). Most of the buildings, including the tram depot (centre), were flattened when a stick of bombs fell across the junction in 1941. Looming over all are E.S. & A. Robinson's paper-bag factories; the near one now Cameron Balloons, the far one awaiting development.

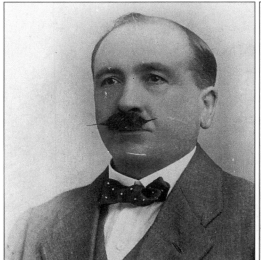 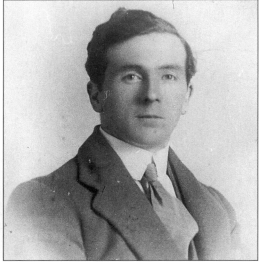

Left: Egbert Nathanial Miles, the eldest of twelve children of the village school master at Brynberion in Pembrokeshire, came to work for an uncle, John Picton, a draper on Redcliffe Hill. In 1884 he bought his first shop in Cannon Street. He made a fortune selling a new type of gentlemen's braces, first pioneered in America, and soon after purchased the shops on either side and knocked them into one. From the street, the three identical shop-fronts inspired a famous Bedminster joke: 'How many miles from Bedminster Town Hall to the London Inn?' Answer: 'Three – Miles, Miles and Miles'. [M27]. *Right*: in 1905, at the age of 17, Egbert's youngest brother, Thomas Marsden Miles (pictured), joined him and was still working there in 1974. His sisters, Marguerite Jane Miles and Mary Ann Miles, also worked there for a while, and two sons and a nephew.

 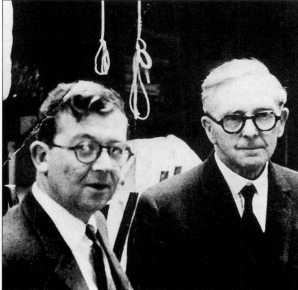

Left: John Griffith Miles had emigrated as a young man to Bulawayo in Rhodesia, was called up and served under General Smith in the invasion of German East Africa. After the First World War he joined the family business. *Right*: David and Marsden Miles in the Cannon Street shop.

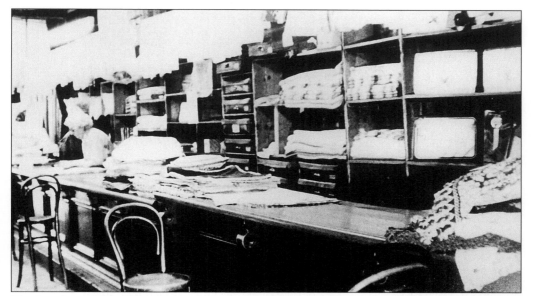

The interior of Miles' Haberdashery had a unique flavour. The merchandise was stacked in hard brown cardboard boxes and was displayed on long mahogany counters to customers who were requested to sit on high wooden chairs. The floor consisted of unadorned bare planks, through the crevices between which quite a few gold sovereigns were found to have rolled when the premises were dismantled in the mid-1980s.

Miles' annual outing, c. 1948. The staff of Miles' were much beloved locally for their old-world courtesy and attentiveness. From left to right, back row: Griff Miles, Ted Ellis, John Miles (son of Thomas Marsden, a well-known public figure) and Mr Jarrett Jones. Middle row: Miss Blackwell, Miss Mead, Mrs Fisher, Miss Matthews, Miss Adams, Mrs Synnuch (hidden is Mrs Bishop). Front row: Miss Woodland, Miss Stevens, Miss Bryant, Mrs Pilgrim, Miss Wright.

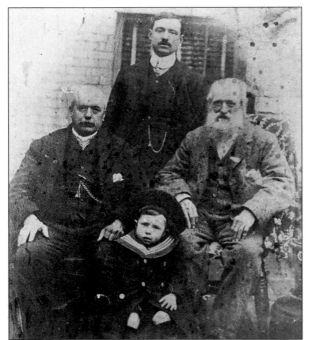

Four generations of the Collard family who established a celebrated chain of butcher's shops in Bedminster. Of French Huguenot extraction, they came to Bedminster *c.* 1850 from Spaxton in Somerset. Edward Collard (seated right) was the cousin of Alfred Daw Collard, the poet-butcher who built Poet's Corner, North Street. In 1882 his son, Charles Edward Henry Collard, had a butcher's shop on Redcliffe Hill and later at No. 5, The Mall, Clifton. Alfred (standing) worked for his father but fell out with him. Taking his wife Louise and the baby, Alfred Henry (seen here in a sailor suit), and all their clothes in a pram, they walked until they came to an empty baker's shop in North Street. 'That'll do,' said Alfred; so began the famous North Street Shop.

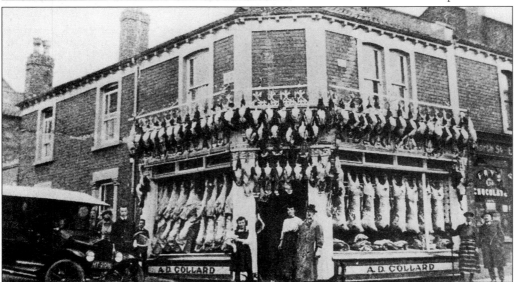

Alfred and Louise Collard in the door of their shop some time before the First World War. At that time it was customary to display meat outside; the poultry show at Christmas was especially magnificent. The elaborate metal brackets on which the birds were displayed are still there. Louise Collard was a well-known Bedminster personality and ran the family business with a firm hand until well into her nineties. She was born into the butchery business, being the daughter of Mr and Mrs Woodhall who ran a butcher's shop in East Street, Bedminster. Many will still recall her at the shop, her hair brushed up and twisted into a coil on the top of her head and held in place with tortoise-shell combs. She always wore a pristine white starched shop coat and in the winter had a short black fur cape round her shoulders for warmth.

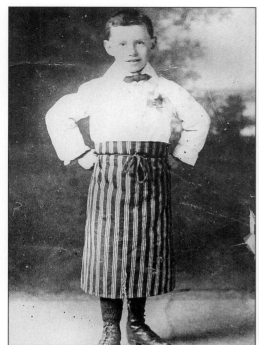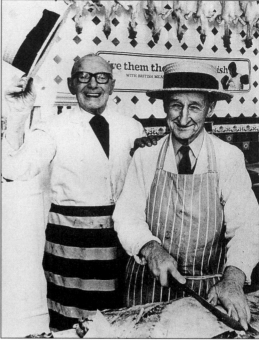

Left: Alfred Henry Collard, son of Alfred Daw and Louise Collard, reared in the butchery trade from the cradle. Unfortunately, his strong-minded mother lived to a great age so he never had much chance to manage the business on his own. *Right*: Alfred Henry Collard and his assistant, Ernest Harwood, *c.* 1977. The straw boaters, striped aprons, the multi-coloured wall tiles and, behind, the Victorian parlour with knobbly furniture, overmantel and tasselled fringe, together with the most solicitous service, were hallmarks of Collard's in its heyday.

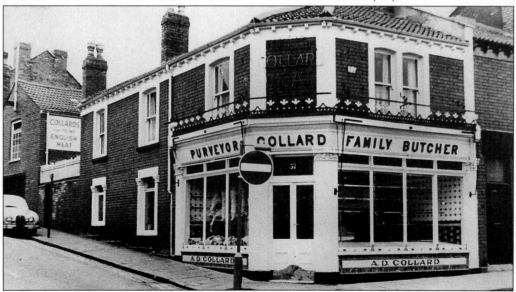

Recent photograph of Collard's shop, North Street. Still a butcher's and still called Collard's but the family have moved elsewhere.

Poet's Corner, built on the corner of Merrywood Road and North Street in 1882 and adorned with a bust of a poet long thought to be Southey, Coleridge or Wordsworth, all of whom had remote connections with Bedminster; but actually to commemorate the effusions of the butcher Alfred Daw Collard. He composed his accounts in rhyming couplets and wrote ballads which he sold in the shop for 1d in aid of the General Hospital. One entitled 'The Redcliffe and Bedminster Christmas Meat Show of 1885' names twenty-six butcher's shops between North Street and Redcliffe Hill in that year. His brother James Collard was invalided out of the Crimean War where he had written some horrific letters from the Heights of Sebastopol. In his will he left his shop to his cousin, the other Alfred Daw Collard (*see previous page*), on condition he paid £10 a year to his brother James. At Poet's Corner, the Bedminster miners could buy a candlestick for 6d to fasten to the peak of their caps before the introduction of safety lamps. [M5, M10, M13].

Mr John Ephraim Winstone, Hosier and Hatter, went into business at 28 East Street (opposite Wills' clock) in 1898. Until the Shops Act of 1912, the closing hours at Winstone's were 9pm on the first nights of the week, 10pm on Fridays and midnight-12.30am on Saturday nights and no early closing. For thirty years his window dressing, especially the summer display of straw boaters, was equal to none and did much to establish Bedminster's reputation as a shoppers' paradise. Before the coming of the big stores and supermarkets the small shops competed with each other for the excellence of their facia boards and sign-writing and the originality and diversity of their window displays. Mr J.E. Winstone retired to Long Ashton and died in 1942.

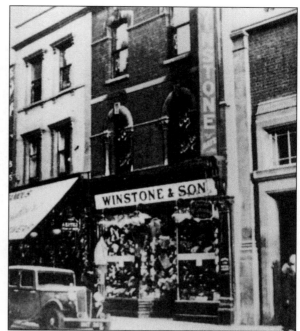

The quality of Mr Winstone's window dressing owed not a little to the flair of his son, Reece Winstone, who was later to become the celebrated photographer and publisher of books of historic Bristol photographs.

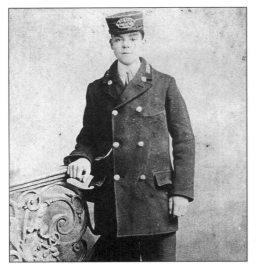
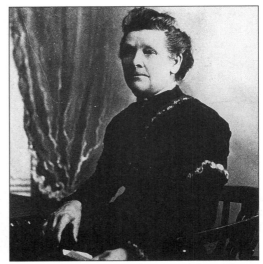

Left: Charlie Plaster, founder of the chain of greengrocery stores, was the son of Sam Plaster who made his living as a scavenger. With horse and cart he collected 'house scrapings' that were heaped in the gutters (before municipal dustmen were thought of) and dumped them in the watery meadows at Ashton Gate, for which he was paid 1/- a cartload by local farmers. The return trip to Bedminster with a cart load of vegetables does not say much for hygiene and perhaps contributed to epidemics of typhoid and cholera. [M30]. *Right*: Charlie's mother, Harriet Bowles, was a local giantess of 6' 2". At 70 she could still heave a hundredweight of 'taters' on her shoulder.

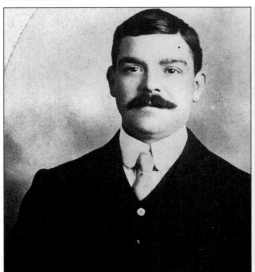
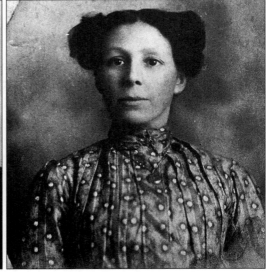

Left: as a lad Charlie worked as a 'clippy' on the horse-trams from Knowle to Hotwells. His route took him past Robinson's paper-bag factory at Bristol Bridge where a pretty girl used to wave to him. He left the tramway company, went to work for a greengrocer and married the pretty girl from Robinson's factory. *Right*: Lillian, Charlie's first wife, *c.* 1907. About this time Charlie set up his own greengrocery business at 14 West Street. Within twelve months he was joined by four of his five older brothers, Arthur, Harry, Philip and Sam. While Charlie and his wife ran the shop, the brothers went from door to door with a horse and cart.

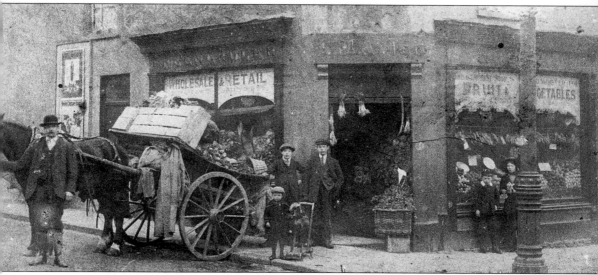

In 1909 Charlie moved to his second shop on the corner of West Street and Kent Street, seen here. Over the door appeared the initials 'SPQR'. When asked what it meant Charlie replied, 'Small profits, quick returns'. The next generation of Plasters was growing up, were brought into the Plaster empire, and by 1930 there were seventeen Plasters all engaged in the greengrocery business at the same time. In 1925 Charlie left the shop for a while to become landlord of the Sportsman's Arms, West Street (now the Black Cat).

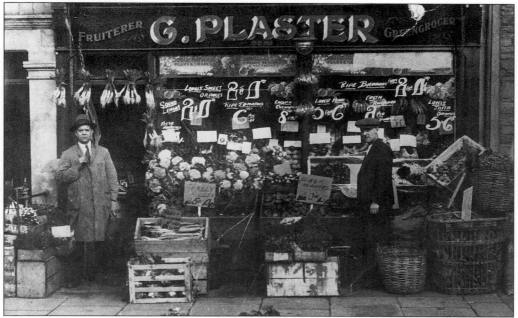

In 1936 Charlie married again and opened new premises at 252 St John's Lane. In the great depression, especially during the General Strike and Coal Strike, Charlie had 15 cwt to a ton of potatoes tipped on the floor of the stable next to his shop every two weeks for the families reduced to the verge of starvation. Charlie Plaster junior continued to run the West Street shop until it was destroyed in an air-raid in 1941.

Walter Henry Bosley, master baker and confectioner from Churchill Green, bought the baker's shop at the foot of Bedminster Down in 1897. It became the principal bakery for miles around and an oasis of calm in what was still a very rough area. He and his wife were Methodists, co-founders of the Salem Chapel in Trafalgar Terrace, and they imposed a spartan regime on their seven children. 'Father used to pick men out of the gutter, wash them, give them a supper and preach them a sermon,' said his son, Walter Bosley junior. 'Many owed their lives to him, and their jobs. Those he saved from drink he often took on at the bakery. He employed half the ruffians of Bedminster Down.' [M8, M9].

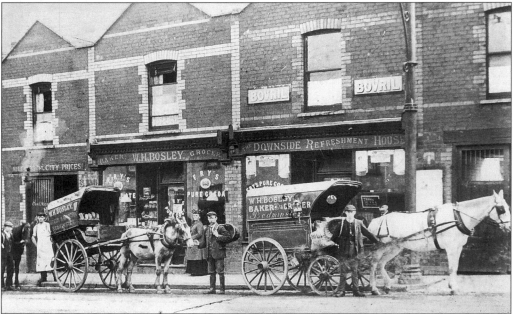

Walter Bosley died of cancer in 1908 and his wife and children had to struggle to keep the bakery going; her eldest son, William never had a childhood: 'At the age of 12 he looked like a grown man. Fred was 'chesty' so he couldn't work in the bakery. He delivered bread all his life, so did our Mabel in all weathers, with gaiters over her knees and an old horse which fell asleep and fell down in the traces'. William was called up in the First World War and Mrs Bosley had to employ C3 men who were so physically unfit that she had to lift hundredweight sacks of barley meal corn on her own back. By 1918 she was a wreck. Fortunately her sons were now old enough to take over and their mother married again and retired.

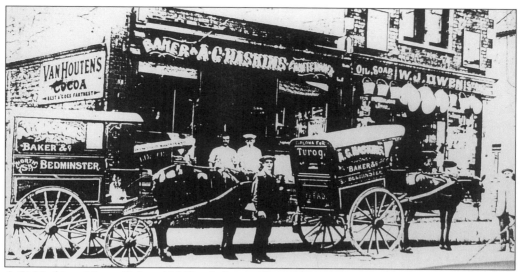

A.C. Haskins, Master Baker, 115 North Street. His son Stanley, who spent his whole life in the trade, says that a 55-56 hour week was quite normal and it was poorly paid. The photograph dates from *c.* 1912 when a 2 lb loaf cost 2½*d*, pasties ½*d* or seven for 3*d*, matches 1*d* for a dozen boxes, kidney beans 1*d* a pound and beer 4½*d* a pint. Men and women hurrying to the 6.30am shift at Wills' called in to snatch a 'Chester' which meant a doughnut and one cream-slice for 1*d*. These were already wrapped and lined up on the counter. In 1916 Mr Haskins was made bankrupt and all his children had to go out to work. [M16].

A loaf-shaped delivery van, *c.* 1930, belonging to Edward Luton of 226 North Street and later 84 and 82 East Street. He was an outstanding baker, winning national awards, aiming always at the best and expecting and usually receiving the highest standards from his staff. He was a dedicated Christian, worshipping at the Philip Street Baptist Chapel, and was a founder of the Bedminster Tabernacle in Palmyra Road. [M24].

Walter Theodore Chivers, Master Builder and Plumber, 2 Victor Road, West Street. He specialised in the Edwardian era in supplying 'Athena ceramic vitreous lavatory combinations' to the homes of the well-to-do. At 2 Victor Road he raised eight daughters, Millie, Elsie, Mabel, Marie, Norah, Nellie, Gladys and Effie, and in 1901 he bought the old Manor House in Bishopsworth.

Left: Walter Chivers with his daughter on her wedding day. [M30, M31]. *Right:* Typical washstand, now at Bishopsworth Manor House; an example of the opulent chinaware fitted by W.T. Chivers.

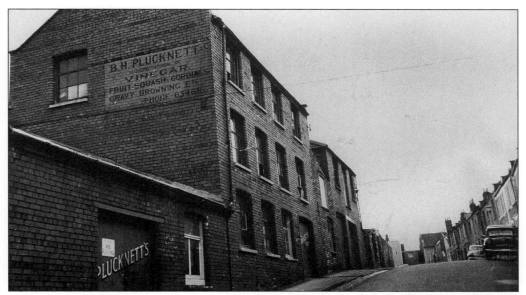

Plucknett's Vinegar Factory, Braunton Road. A well-loved family business remembered by many who, as children, were sent with a jug to collect vinegar from one of the great wooden vats at the top of a steep staircase. The factory was subsequently taken over by Mr Bryan's Cockle Shop in East Street. Both are now defunct.

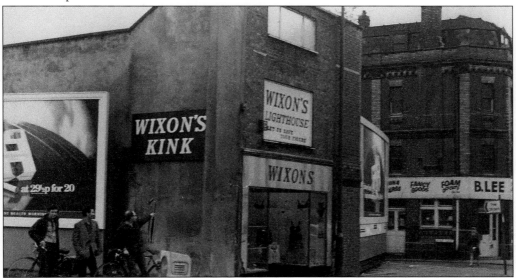

Wixon's Kink. Mr Edward Wixon first established his ladies' underwear business in a temporary building at Wilson Parade in 1952. In 1957 the Corporation ordered him to put up a permanent building; in July 1958 this opened and in November the same year he was told it would have to come down to make the approach to the second Bedminster Bridge. Mr Wixon refused to comply. 'They can't close me down; our uplifts are too strong,' he put in the window. For some years, the underwear shop – now renamed 'Wixon's Kink' – defied the Corporation and produced a 'kink' in the new roundabout system. The kink finally came down when Miss Melhuish, the late Mr Wixon's business partner, retired in 1978. On the pavement with the bike is Anton Bantock pointing out the 'kink' to two Arab students in 1975. [M1].

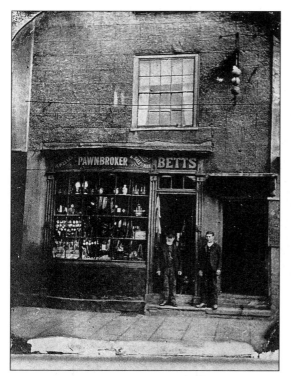

Betts Pawnbrokers, Bedminster Parade (later 'Abington' and finally 'Windmill'), was a local institution always busy on Monday mornings for pawning your best suit and Saturday evenings for getting it out again. Mr Davies, who had a waxed moustache and fingers covered with rings, would not tolerate any haggling. You would open your parcel on the counter and say, 'Father's best shirt, and I would like ninepence on it please.' Before you had time to finish he would shout, 'Sixpence … take it or leave it. Next, please.' You took it – you didn't dare go home without a few coppers. The favourite tale was that people had even pawned a sheep's head, wrapped up, as the pawnbroker did not always open the parcel. [M32, *Water under the Bridge*].

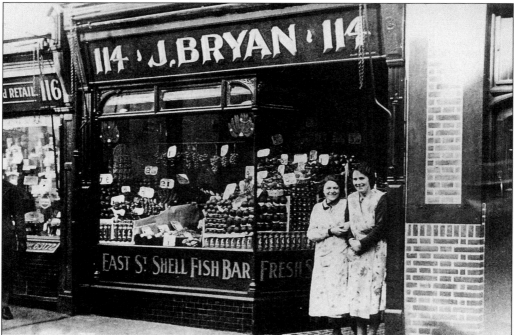

Jack Bryan's Cockle Shop, 114 East Street, *c.* 1937, with ladies wearing typical 'cross-over' overalls of the period. His fruit, shellfish, laver and, in a more distant time, cooked cow's udder made this one of Bedminster's best loved shops. It survived until the late 1980s.

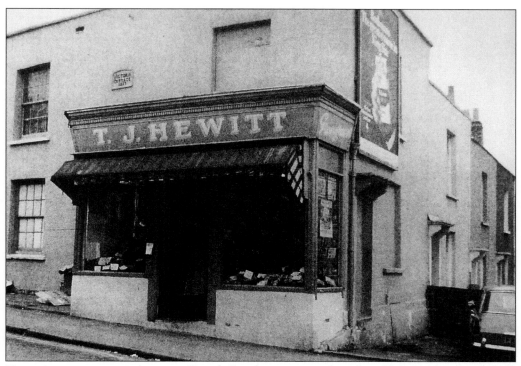

Hewitt's miniature greengrocery, British Road, was a casualty when Victoria Cottage (1837) was recently refurbished.

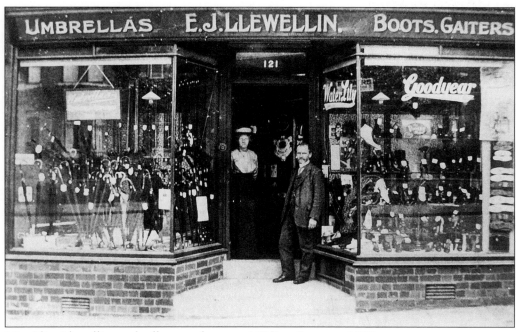

Miss Eliza Llewellin, umbrella manufacturer, 140 East Street, *c.* 1910.

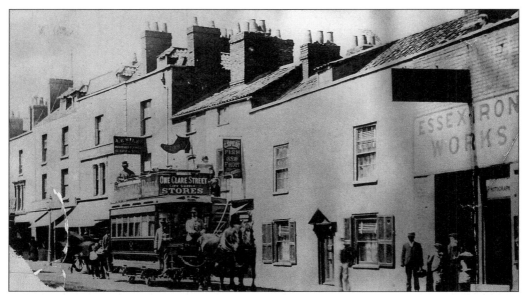

Horse-drawn tram, *c.* 1880. Trams to Ashton Gate and Bedminster Down arrived in the 1860s and were electrified in 1899. The distinctive blue and cream carriages and exposed upper deck continued a rather appealing Bristol idiosyncrasy until the whole system south of the Avon was brought to a sudden end by the Blitz in 1941. Among the old shop-fronts (now replaced by Boots) can be seen the sign of 'Cloggy Davies' who sold wooden clogs, tipped with iron for miners, mill workers and the like.

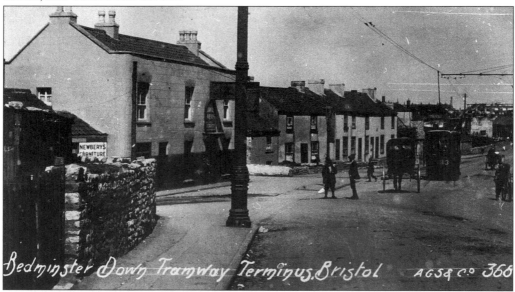

At the Miners Arms, bottom of Bedminster Down Hill, the driver reversed the overhead arm and began his return journey. The fare from Bristol Bridge to 'Bedminster Downs' was 1*d*. The Miners Arms, formerly a smithy, was much frequented by miners working in the South Liberty Lane Colliery. It was opened in 1843 by William Dufty, a retired sea-captain, and the licence remained in his family for the next four generations until his great granddaughter, Madge Selvidge, retired in 1982.

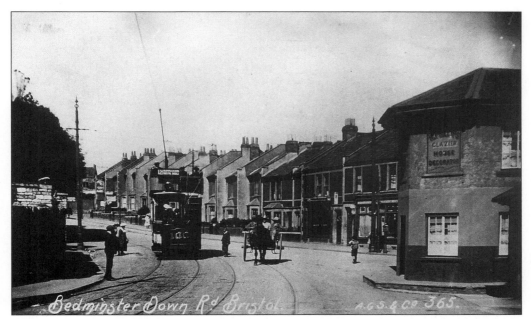

A tram about to ascend Fire-engine Hill, West Street, *c.* 1912. On the right is the eighteenth-century Bedminster Down toll-house on the corner of West Street and Parson Street. At the top of the hill can just be seen the farmhouse of Holliman's smallholding.

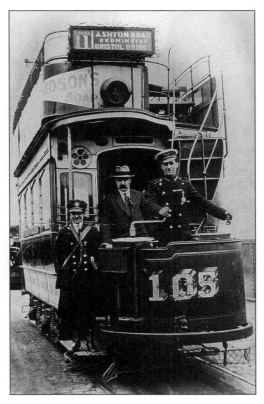

On Ashton Bridge, on the Ashton Gate–Redcliffe Street route, *c.* 1916, when women were first recruited as 'clippies' to replace those on war service. The old gentleman is George Humphrey Macey who as a young man worked for a pawnbroker. He married Ethel Kole *c.* 1899 when she was only seventeen. They saved up enough money to buy a sack of sugar from which they made their own sweets. They subsequently opened a confectionery shop at 93 Redcliffe Street, their second at 125 East Street and later had another shop in North Street. [M28].

Bedminster has a remarkable heritage of school buildings representing every stage in the evolution of popular education, from the schools of the religious societies through to the state schools of the twentieth century. Only a fragment of the Church of England's National School of 1837 survives at the top end of East Street – a bricked-up doorway and a cast-iron barrier to prevent children running out under the wheels of draymen's carts. But a good idea of it can be gained from the design on a commemoration cup and saucer belonging to Ted Hill's late father of South Street.

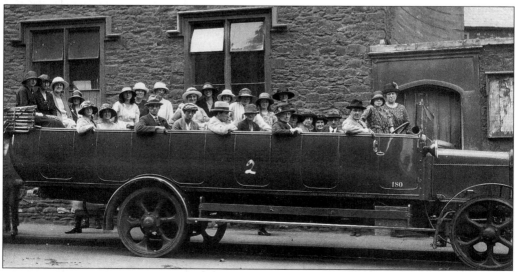

The long, two-storied building with mock-Tudor drip-stones and gothic doorways at either end can be seen in the background of this photograph of a Hebron Chapel outing *c.* 1920. Note the solid rubber wheels of the charabanc and the formidable array of hats. There seems to have been little protection to prevent them blowing away.

The little house on the same site as the National School was occupied by the Sisters of Charity attached to St John's Church. They distributed to poor families food which was donated by the regular worshippers of St John's on 'pound days' – you had to bring a pound of food.

The staff of St John's National School, c. 1928, photographed by the headmistress, Miss L.B. Edwards. From left to right: Miss B.L. Bruce (later Sherman), Miss L.M. Palmer, Miss A.L. Davidge, Miss E. Cottle, Miss R. Garrett (later Mrs R. Chivers of Bishopsworth). [M7].

The British and Foreign Society of the Free Churches came hot on the heels of the Church of England and built the British School in 1846 in Back Lanes, subsequently called British Road. It was a handsome mock-Tudor building with leaded panes and two doors, one for the boys and the other for the girls. [M10].

It soon proved too small, and in 1855 a second floor was added and the girls moved upstairs. This made it for many years the largest and most imposing building in Bedminster.

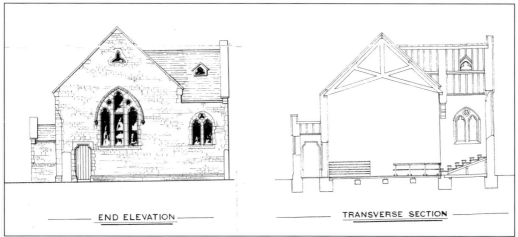

<div align="center">END ELEVATION TRANSVERSE SECTION</div>

In 1867 an infants' school was added on the right. In 1877 there were 332 boys, 302 girls and 200 infants attending the British School. These drawings are from the original architect's designs for the building in the Somerset Records Office. When South Street Board School was built in 1895, the children were transferred to this more modern and spacious building, and the British School became a warehouse for E.S. & A. Robinson. It was used as an air-raid shelter in the Second World War and subsequently as a bicycle factory and machine-tools workshop.

Drawing made in 1994 showing the British School now empty and derelict but still commanding a complex of Victorian buildings including Hebron Chapel (1858) and Sunday school (1887) on the right, Hebron Road and North Street (in the centre) and, in the foreground, Mount Pleasant Terrace (1848) which was constructed of Bath stone and is the most attractive of Bedminster terraces. This part of Bedminster is being considered by Bristol City Planning Department as a conservation area. In April 1997 the old British School was gutted by fire; its demolition would be a tragic loss. [M9].

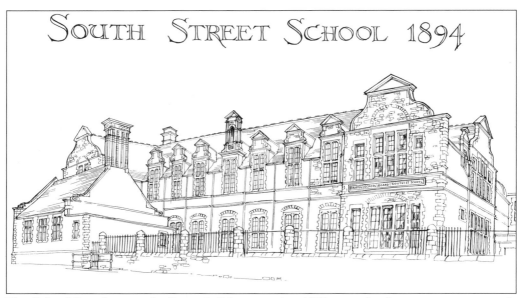

SOUTH STREET SCHOOL 1894

The School Boards set up by Forster's Education Act 1870 were the first attempts to provide comprehensive education for all children. At first they were neither free nor compulsory. Windmill Hill School (1887), Boot Lane School (1895), South Street School (1894) and Merrywood (1897) are enduring monuments to Victorian enterprise. Dressed-stone windows, Dutch gables and prodigious redbrick chimney stacks are the hallmark of the Bristol Board schools of this period.

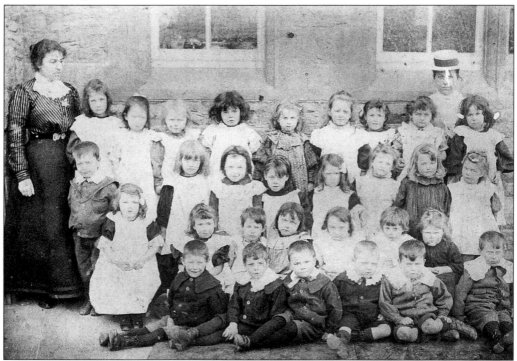

South Street Infants, 1901-02. On the left is Miss Thomas, the headmistress.

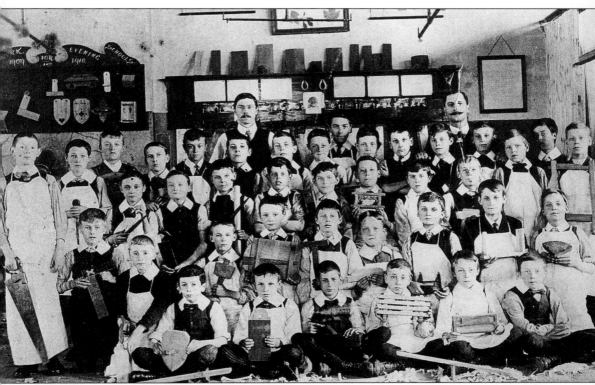

South Street woodwork class (1909) held in the Albert Hall (part of the Albert Inn, West Street). From left to right, back row: Mr Jenkins, assistant teacher (later killed in the First World War when the breech block of a gun he was cleaning blew up), and Mr Jones, head teacher. Back row, standing: Edgar Eastman (lived in Hall Street. He was a member of East Street Baptist Church and sang in the Male Voice Choir. He was known to many as 'Ginger' because of the colour of his hair); ? Fisher (lived in British Road. His father was a plumber with a business in Clifton); -?-; Ted Griffith (who became a miner in South Wales); Bernard Anstey (lived in Garnet Street); Ernie Bevin (lived in Zion Road); ? Glendening; -?-; -?-; -?-; Donald Hall (lived in Clifton View which formerly ran from South Street to Zion Road); -?-; Frank Nash (lived in Ruby Street); -?-; -?-; -?-. Next row: -?-; -?-; -?-; Bert Brett (lived in the Chessels. Father kept an oil shop in West Street opposite the Red Cow; -?-; -?-; Fred Hill (born and lived in 3 Stanley Terrace; he provided the photograph and the information); Arthur Bridges (of 14 Stanley Terrace). Next row: -?-; Reg Hunt (Chessels); Alf Flowers (Churchlands Road; he later worked in Fry's Union Street); George Clark; -?-; -?-; two brothers named Hall (lived in corner house, Upper Pearl Street and Chessels. Their father was a foreman in the quarries at Failand and rode to work in a pony and trap. The one on the left sang in St Aldhelm's Choir; his brother took up quarrying, and became manager and director of Bristol City FC); ? Harris (lived in Victoria Crescent opposite Toogood's saw mills). Front row: Edward and Fred Bennett (cousins; Edward lived in Argus Road and Fred at the top of Parson Street); -?-; -?-; Ernest Fry (lived in the Chessels); -?-.

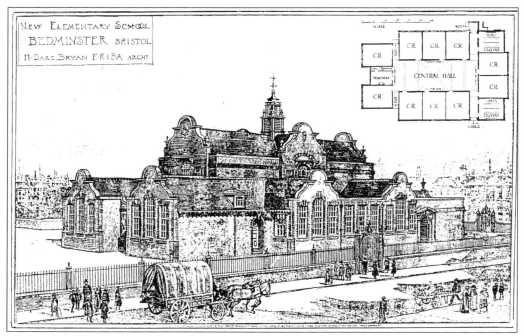

Merrywood Elementary School, one of the first Council Schools, constructed after the dissolution of the School Boards in 1906. It was built on the site of Merrywood Hall (*see p. 31*). A splendid design in stone and terracotta brick with fine Flemish details, outstanding wrought-iron gates, and an elaborate lantern (rather more ornate in this architectural drawing than the one actually built).

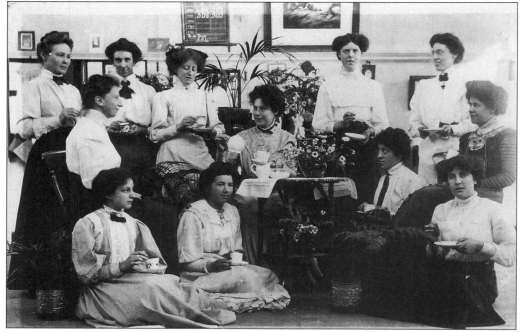

Staff of Merrywood Elementary School at the inaugural tea-party, 1908.

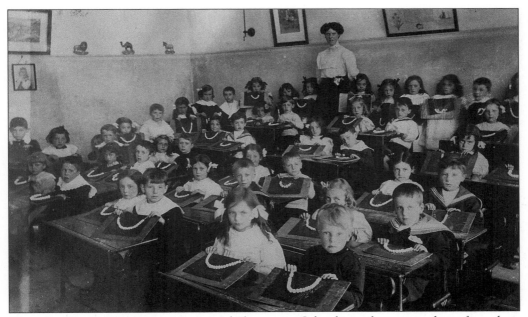

Threading beads. Children at Merrywood Elementary School in sailor-suits and pinafores show off their work, *c.* 1907.

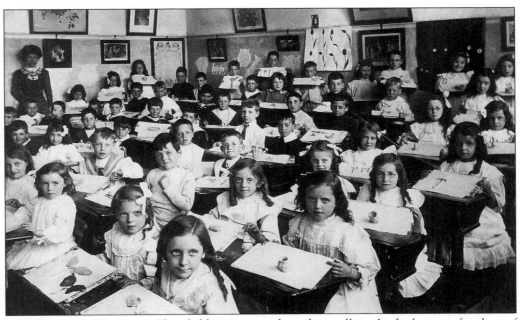

Modelling with Plasticine. The children seem to have been allowed a little more freedom of expression in this exercise.

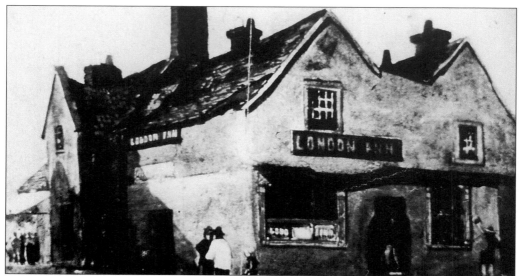

The London Inn. From the *South Bristol Gazette* 1884: 'A tortuous grimy street is the main thoroughfare of Bedminster. Medieval gabled homes, sheds and tan-pits drag their unsightly lengths from the rickety bridge that spans the Cut to the pretentiously named but antiquated hostelry known as the London Inn. On the outskirts of this chaotic mass of bricks and mortar flowed an open cess-pool, the odiferous Malago; and very mal it was ... with its bed of cabbage stalks, broken crockery ware, old boots and nameless horrors for which as a sepulchre for dogs and cats, it has become famed the country round.' The London Inn was rebuilt *c.* 1895 on its present site several metres north of the original to allow access to British Road.

The Cross Hands on Bedminster Down. The tribe of Halls, descendants of the first recorded publican, Isaac Hall (*c.* 1833), and his son Joseph, rejoiced in large families with uncouth nicknames, e.g. 'Spogle', 'Raggs', 'Babby Bits' and 'Gobs'. The Cross Hands served generations of miners; for years it was such a rough area that travellers to Bishopsworth and beyond made a wide detour to avoid it. By 1878 almost every cottage on Bedminster Down was inhabited by Halls. Maudy Long's shop alongside was demolished in 1968 but it is said her ghost still haunts the pub.

The Spotted Horse, West Street, long since demolished, but replaced on almost the same site by the Albert Inn. Until her death in 1923, aged 83, the landlady at the Spotted Horse was Sarah Ann Jones. This water-colour, dating from *c.* 1884, was painted by a penniless German artist who couldn't pay his bill. 'Then paint a picture of my pub!' said Sarah Ann Jones. The other illustrations on these pages are almost certainly by the same hand, so he evidently made a habit of not paying his bills. [M23].

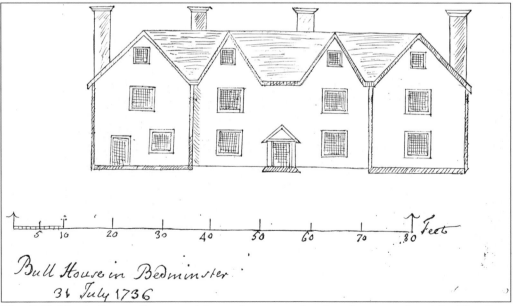

The Bull, North Street, from an eighteenth-century drawing. It was replaced by The Star, *c.* 1900, and is now called The Florikan and Firkin It was the scene of a shocking tragedy in 1827 when Mr Martin, the publican, purchased a young tiger from the docks and displayed it in a cage to attract more trade. The novelty soon wore off, so he hired a man, called Joseph Kiddle, to get inside the cage with the beast. A large crowd gathered, only to see poor Mr Kiddle mauled to death. [M4].

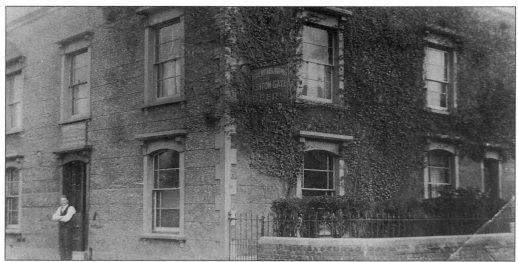

The Brewer's Arms, corner of South Street and Gladstone Street, in 1932. In the doorway is Mr Ewart Jones, the publican, who was very proud of his collection of stuffed birds, clay-pipes and a giant grandfather clock, which he put in the doorway to save being bothered by the local people who called in to ask the time. It received a direct hit in the Good Friday Raid, 1941. Mr Jones was in hospital but his wife and son, Philip, and Jack West who was helping out that night were trapped in the cellar. After some time groping round in the dust and darkness, they crawled out through the barrel hatch. Jack West later died of the injuries he received moving barrels to facilitate their escape. [M22].

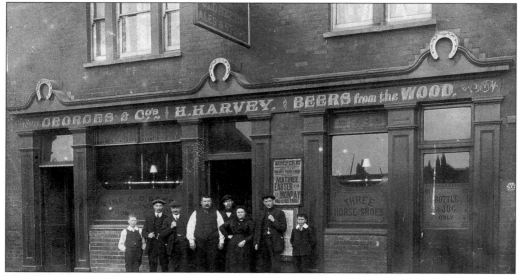

The Three Horse Shoes, No. 206 West Street, built during the early part of the twentieth century. The side door was for bottle and jug – usually frequented by ladies who were rarely seen in pubs before 1914, though many would be fetching and carrying for their menfolk. Henry Herwig was of German extraction but traded under the anglicised name of Harvey, by which the family was known for many years. This photograph was taken shortly after they took over the licence in November 1908. Centre is Henry and his wife Elizabeth, their two older sons Henry and Christian, with some of the customers.

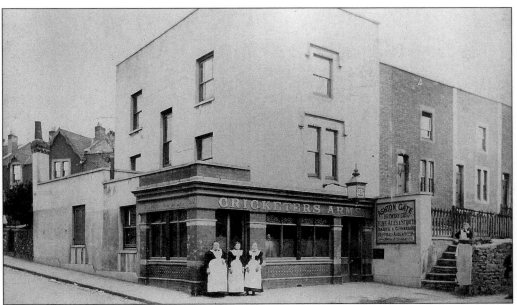

Above: the Cricketers' Arms, Greenway Bush Lane. In the window is the landlord, Mark Howell; before the door are Aunty Cable, Fanny Howell (the landlord's second wife), and Louise Howell (his daughter by his first marriage). The pub was destroyed in the blitz; and many other Bedminster pubs went out of business in the post-war period. The great boom in public houses and beer-houses was in the 1880s and 1890s. Here are the figures: 1843 (33); 1864 (24); 1884 (79); 1904 (101), 1924 (99); 1944 (71); 1954 (54); 1972 (48); 1975 (28). From left to right, *below:* Fanny Baker who later married Mark Howell, Aunty Cable looking very straightlaced, her brother (seated), Lucy's brother, Bill.

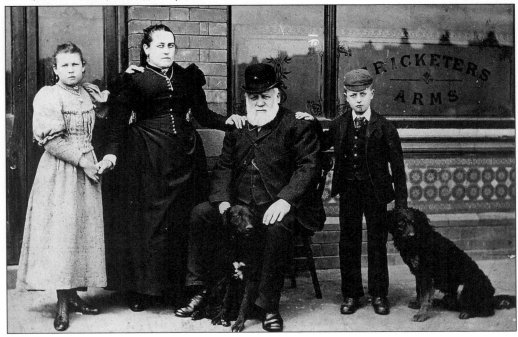

The Colston Arms, on the corner of Providence Place and Whitehouse Lane, *c.* 1968. This is the view from the Windmill Hill railway bridge; the area is now redeveloped with the National Federation of City Farms' building on the left and a green space on the right. Next to the Colston Arms was a tiny cockle shop owned by Mr Wallace, a blind man; he used to boil his cockles in a back room. Cissy Wallace, daughter of the publican, later took over the shop to sell canary seed. Opposite was Fowler's the bakers; it was burnt out by incendiaries during the Second World War. During air-raids Eddie Watkins, son of the landlord, preferred to take cover under the railway arch rather than go down into the cellar.

Spring Tavern, Philip Street, 1968. Philip Street began as a rope-walk *c.* 1840, built in the 1860s. In 1883 there were 93 houses and five pubs; now there are five houses and one pub. At the end, on the left, is the Philip Street Baptist Chapel and beyond is the W.D. & H.O. Wills extension building of 1909 which was demolished in 1986 for the building of the ASDA supermarket. The Spring Tavern is now derelict; the roof fell in 1986. The Steadfast closed *c.* 1960, and The Swan was bombed flat in the blitz.

The Apple Tree, Philip Street, 1968. This was formally called The Maltsters Arms, which may take its name from the malt-house just visible opposite on the corner of Stillhouse Lane and Willway Street. This prodigious stone building with small, barred windows once had two distinctive pyramid-shaped roofs. It dates from the 1860s but looks older. Willway Street was blasted by land-mines; out of the crowded courts and alleys of Stillhouse Lane, cleared in the 1960s, the malt-house survives as a night-club surrounded by new industrial premises.

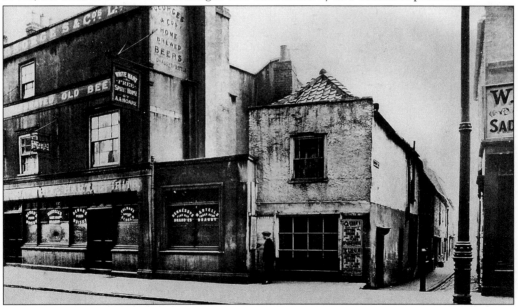

The White Hart, East Street, c. 1910. This fine eighteenth-century inn survives unchanged but Brewer's Place, typical of the dingy courts and alleys once infesting this part of Bedminster, was replaced by the elaborate National Provincial Bank (now NatWest) in 1913. Bedminster pubs still sport many names which betray their rural origins: the Barley Mow, Spotted Cow, Plough and Windmill, Red Cow, the Hen and Chicken, etc. Eighteenth-century publicans appealed to the proclivities of North Somerset farmers who travelled into Bristol on market days and resorted to their favourite tavern once their business was done. Their horses knew the way home even if their owners were past caring.

The Wool Warehouse, corner of Sheene Road and West Street, *c.* 1960. In 1811 the ground floor of this building was rented for £10 a year by the Methodists as the first chapel in Bedminster. John Wesley passed through Bedminster six times between 1748 and 1776 and preached more than once at the 'Paddock'. The warehouse served the community until 1837 and survived until the 1970s when the site was cleared for the premises of Peter Nisbet & Co. [M1, M20, M21, M29, M30, M36].

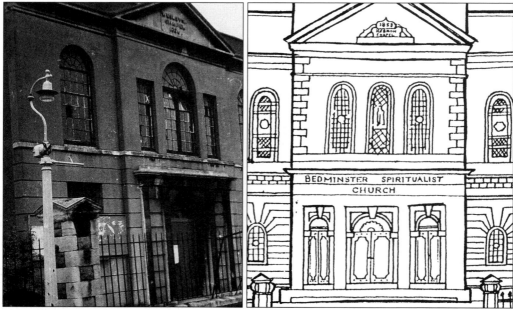

Left: the first Wesleyan chapel in Back Lanes (later Victoria Road, now British Road) built 1837 and photographed in the 1970s, shortly before its demolition. It was a fine neoclassical building and could accommodate 400 people. It was opened by Jabez Bunting, President of the Methodist Conference. The great schism between 'Wesleyan Reformers' and the parent community of 1849 reduced membership from 343 to 71; the schismatics moved out to the British School and in 1858 built Hebron Chapel round the corner. *Right:* Hebron Methodist Chapel is now the Bedminster Spiritualist Church. Its burial ground, much neglected, is a precious corner of old Bedminster and contains among others the grave of 'Princess Caraboo'.

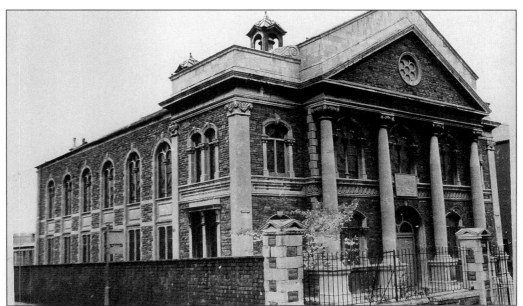

Ebenezer, *c. 1974*. The Wesleyan Methodists had recovered from the schism of 1841, and by 1890 their chapel was no longer large enough. In 1886 they built Ebenezer alongside, arguably one of the largest and most imposing Methodist churches in all Bristol. It could accommodate 1,100. In its heyday, Ebenezer had a larger congregation than any city church. It had four football teams and at least one cricket team; on church outings, fleets of charabancs stretched all the way down British Road (*see p. 76*). There was such a crush of people attending evening services that a policeman had to be on duty.

In 1974-75 Ebenezer was modified. Its monumental façade was torn down and replaced by a more modest one, built further back, and the interior was completely modernised. Externally, the rear part remains unchanged.

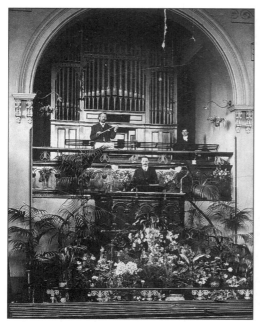 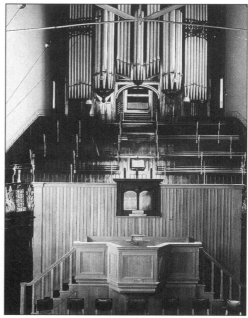

Left: interior of Philip Street Baptist Chapel. In the organ loft are George Lewis and his son Fred and in the pulpit is Revd G. Attwood. In the early years of the century it was a vibrant community in the centre of a high-density inner-city area. Among its early members was John Dingle and the Bollom brothers (*see p. 115*). *Right:* interior of East Street Baptist Chapel. This photograph shows the new pulpit in light oak which replaced the original, installed when the church was built in 1894. This had been a boxed pulpit with rather ornate bracket lights. This modernisation was dedicated to Alderman Edward Parsons JP after his death in 1929. He was a founder member of the church and superintendent of a well-disciplined Sunday school for many years.

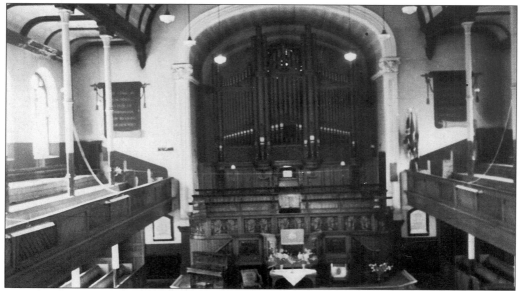

Interior of Ebenezer Methodist Church before modernisation in 1974-75.

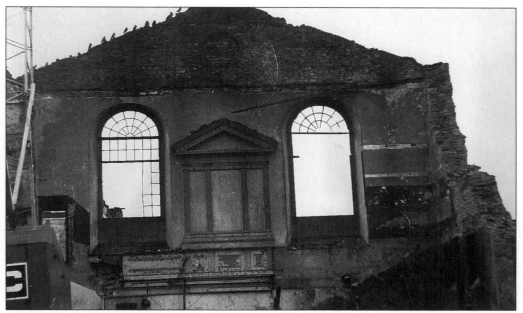

Interior of Wesleyan Chapel, built 1837 and converted to a Sunday school when replaced by Ebenezer in 1887. The photograph shows the final stage of demolition c. 1981. Modern maisonettes now occupy this site.

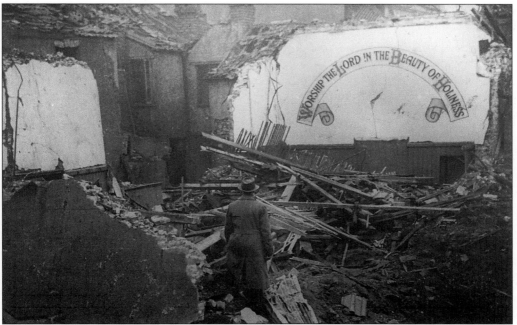

Interior of West Street Baptist Chapel on the morning after it had been destroyed in a raid c. 1941. This was probably the oldest nonconformist chapel south of the Avon. In 1881 there were seven Methodist churches in Bedminster; now there are three. The nonconformist chapels have also suffered from war damage or industrial development of former high-density residential areas, and many have been demolished or converted for other uses. [M29].

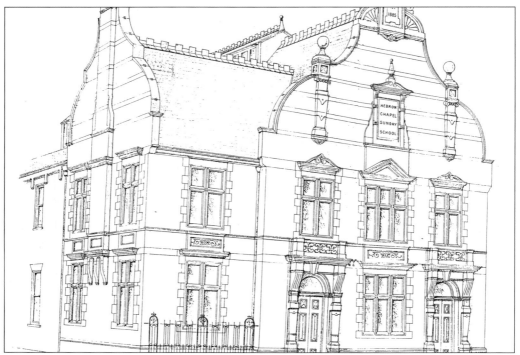

Architect's drawing of Hebron Sunday school, 1885, Sion Road, in a charming mock-Jacobean style in brick with stone facings, Dutch gables, elaborate sky-light and magnificent cast-iron brackets to support the gallery. The building became a warehouse in the 1960s and in 1980 was acquired by an enterprise agency and altered into units for light crafts and offices. The façade fortunately has been preserved and restored to its former glory.

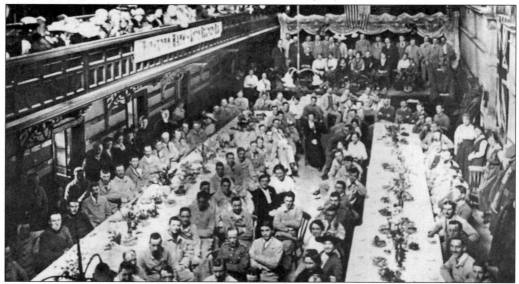

Wounded soldiers entertained to tea in Hebron Sunday school, Sion Road, 1917. Doors to the individual classrooms and ornate iron brackets supporting the gallery can be seen, though these are no longer apparent in the modern conversion of the building.

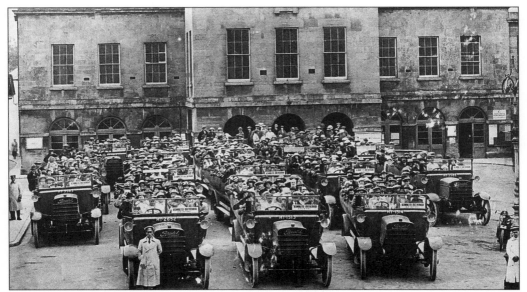

Bedminster Brotherhood outing, 17 June 1922, to Wells, Somerset. Eighteen charabancs carried over 1,000 members of the Ebenezer community. [M25, M27, M30].

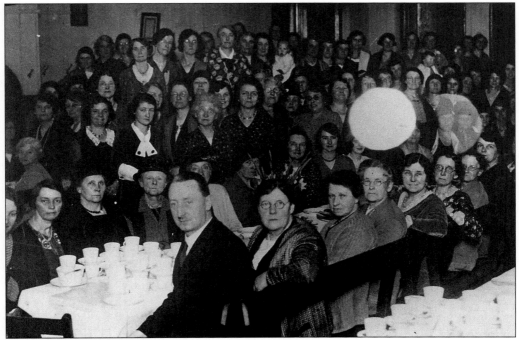

Women's Bright Hour at the East Street Baptist Church, *c.* 1920, gave many Bedminster wives a much needed break from cramped and crowded homes and a tedious and often back-breaking domestic routine. [M8].

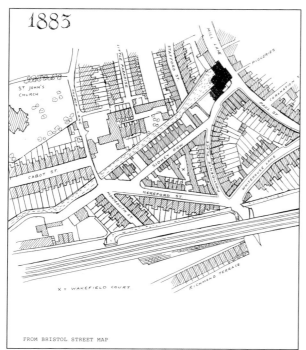

1883

ST JOHN'S CHURCH

MILL LANE

PIGGERIES

CABOT ST

HEREFORD ST

WHITEHOUSE LANE

X = WAKEFIELD COURT

RICHMOND TERRACE

FROM BRISTOL STREET MAP

Compare the street map of 1883 to the same area in 1827-1841 (see p. 36). Every available space had been built on. Workshops, tan-yards and crowded dwellings discharged their waste into the Malago, which twice (in November 1882 and March 1887) burst its banks and flooded the whole of this area in Hereford Street and Whitehouse Lane up to nine or ten feet. Families moved upstairs and were supplied with food by means of a basket tied to a pole, though the flood water would be up to the horse's belly and the cart practically afloat. In about 1898 a flood relief culvert was excavated from St John's Lane to the New Cut, passing under Sheene Road, the London Inn and North Street, and the main channel of the Malago was diverted. A smaller channel, passing inside the railway embankment and traversing the Capper Pass site, still runs.

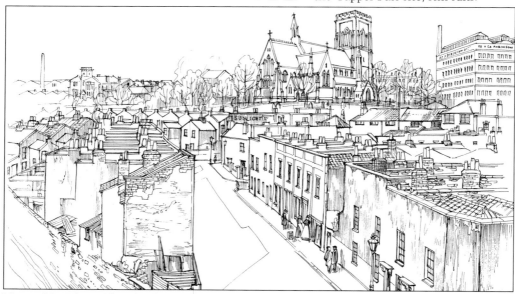

View of St John's Church, the E.S. & A. Robinson building, Hereford Street and Cabot Street from the Railway Bridge to Windmill Hill, c. 1912. There was much poverty in this area in the 1930s. Eli Stenner's boys in Hereford Street went bare-footed and drank their tea out of a basin; there were not enough cups to go round. Sometimes they appeared in clogs, which were usually only worn in breweries and tan-yards. They were not allowed to pay football because the iron tips punctured the ball. Some of the houses, windows bricked up or boarded, were still standing till 1993 when the whole site was cleared for the National Federation of City Farms' new building, The Greenhouse.

96

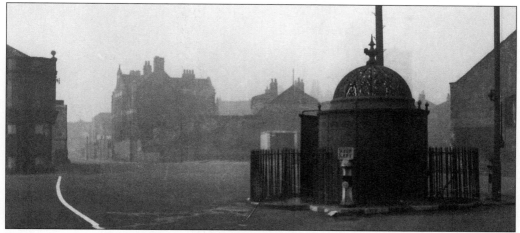

On the diversion of the Malago, *c.* 1898, the old course was filled in and Malago Road built on top. The old St Catherine's Mill and Mill House (shown black on map opposite) were demolished, and in the centre of the large open space created at the junction of Malago Road and Mill Street and Paul Street was placed the 'Stately Dome', a cast-iron urinal, a much-loved landmark till it disappeared *c.* 1965. The photograph was taken *c.* 1964 by Ron Cleeve. In the years between the wars the Mill Lane roundabout became a natural forum for community events, assignations, dances (at the Ford Memorial Hall in Mill Lane) and a venue for Blackshirt demonstrations. Dalby Avenue (built *c.* 1965) now cuts through here and Mill Lane has ceased to be a thoroughfare.

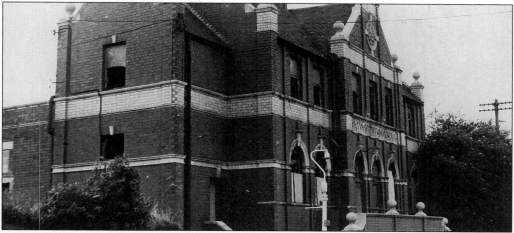

This pretentious building, with a good many stone balls, was the Bristol Dispensary which was supported by public subscription. It was constructed in Malago Road *c.* 1898 and demolished *c.* 1978. Those who could not afford doctor's fees went to the vicars of St John's or St Paul's and asked for a dispensary note. This could be presented at the dispensary for a bottle of medicine. It was always white medicine whatever the ailment. It was also the office of the Poor Law Guardians, known in the 1930s as the National Assistance Board. 'Old Mother Daubeny was head bottle-washer down there,' remembers one local man. 'She must have been the most hated woman in Bedminster.' If you were out of work you could not claim any benefit until her gang had been to your home and subjected you to the Means Test. All items deemed unnecessary, even mats off the floor, had to be sold before you were allowed 5/6. which was considered sufficient to feed two adults and seven children for a week. [M29].

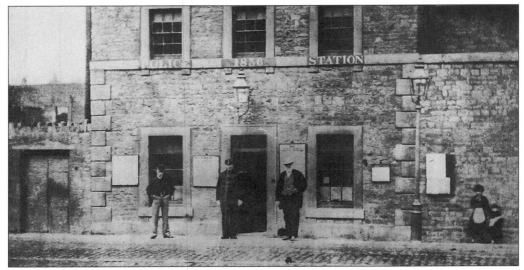

The Police Station in Bedminster Parade was one of the three original stations (the other two were Brandon Hill and St Philip's) established by Act of Parliament in 1834. Constables worked two watches, day and night, were paid 16/- a week, wore dark blue frock coats, black stove pipe hats, white serge dress trousers and an armlet, and carried a 12 in wooden truncheon bearing the royal cipher. In 1850, Bedminster had only one street-lamp and one water-closet, both at the Police Station. [M1, M16, M34].

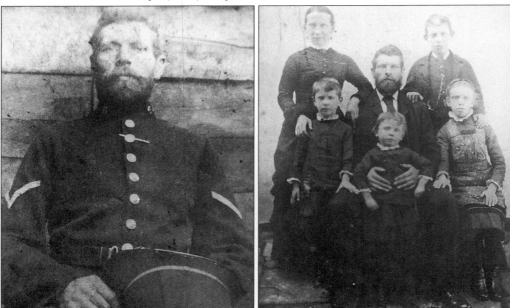

Left: Sgt. Benjamin Gibbs of the Bedminster police, *c.* 1880. He served 21 years, a good and godly man, beloved of his family and neighbours alike. He died aged 42 of Bright's Disease. [M20, M21]. *Right:* Sgt. Gibbs, his wife Emily Jane, and children William, Mabel, Gertie and Ethel, at their home at 2 St John's Terrace. 'Take all my children, Lord,' said Emily Jane, on her knees at his bedside, 'but spare my Ben'. But the Lord took her Ben, and a few months later gave her another daughter, Gracie.

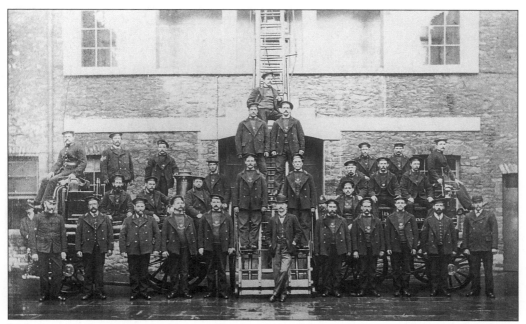

Bedminster Police Station had its own Fire Service with horse-drawn engines and steam pumps. The high central tower was for fire spotting, and the sight of the engines charging out of their station at speed, with sparks flying and firemen hanging on the box, made an impression on spectators that they never forgot.

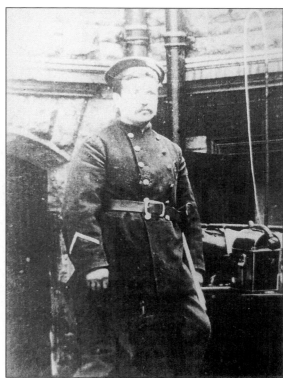

Fireman Arthur Wale, after 25 years with the Bedminster Fire Brigade and due for retirement lost, his life on active service on 27 March 1906. A huge fire at St James Barton, which consumed three factories and nine houses, had actually been extinguished when a factory wall and chimney stack collapsed and several firemen were trapped by falling rubble. Others miraculously escaped but Fireman Wale died within a few minutes of his release. His funeral, attended by his comrades in the fire service and police force and representatives of many public bodies, drew enormous crowds and was given maximum coverage in the press. [M36].

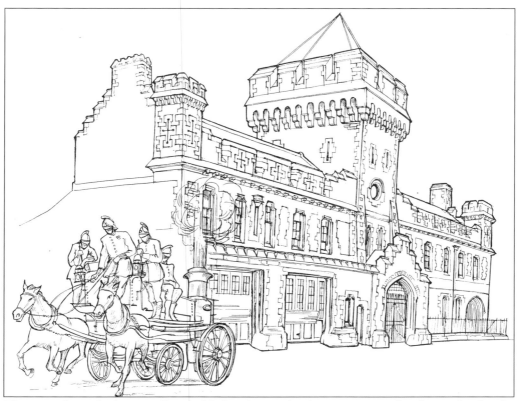

The magnificent Bedminster Fire and Police Station has been unoccupied and semi-derelict for over twenty years.

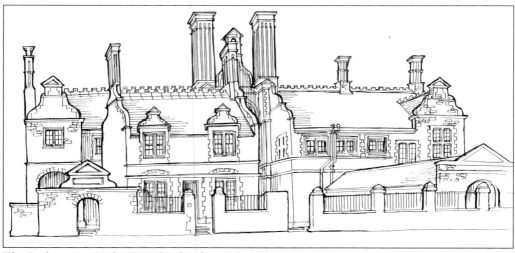

The Bedminster Bridge Board School, popularly known as Boot Lane School, is now a builder's yard and has already lost some of its fine brick chimney and stone entrance gates. [M33].

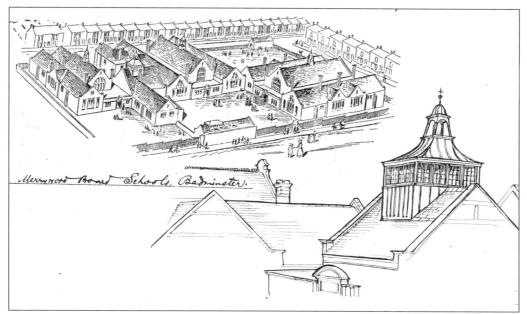

The Merrywood Board School (1897) became the first Merrywood Grammar School. Partly demolished in the 1970s, it became the Southville Community Centre. Its splendid lantern survives.

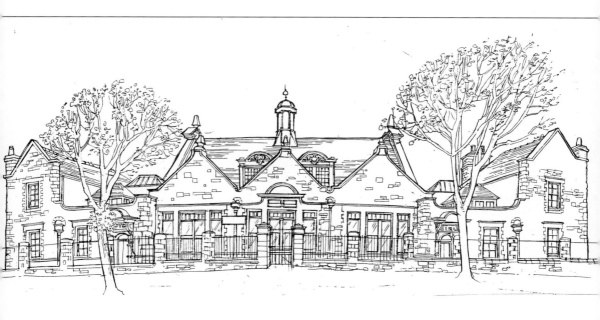

Parson Street School, 1907. This was built to a successful design adopted by the City Council, which took over the direction of education in this year.

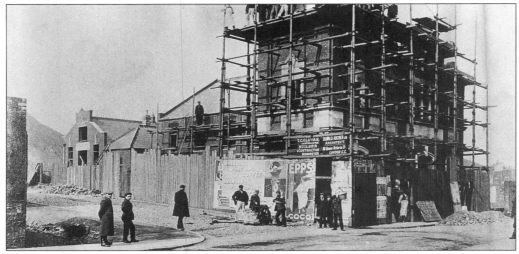

The building of the Salvation Army Citadel in Dean Lane, 1907. The coal-tip of Dean Lane Colliery is clearly visible in the background.

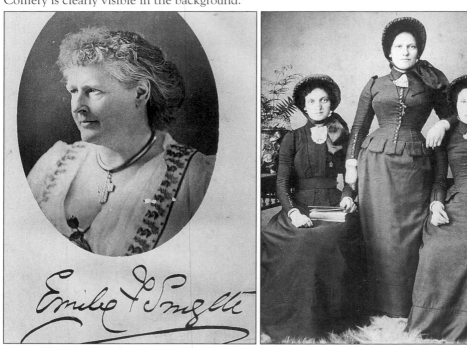

One of the foundation stones was laid by Dame Emily Smyth of Ashton Court (pictured left). In her later years she was much in demand opening shows, planting trees and laying foundation stones. When the Dean Lane Colliery closed she donated the land to the city and it subsequently became the Emily Smyth playground (and wheelie-park). Some said her extensive gifts to charity were expiation for her sinful past! *Right:* Three young ladies in their Salvation Army uniforms, *c*. 1886. On the right is Rose Colston who was born at Shepton Mallet in 1870. In January 1888, when only 17, she married Francis Thorne at St Luke's, Bedminster. They set up home at 48 Philip Street where he founded his family shoe-making firm, F. Thorne and Sons. [M28].

Staff of the Isolation Hospital on Novers Hill which was built in 1892 to handle smallpox cases following two serious epidemics in 1887 (39 deaths) and in 1892 (36 deaths). William Gibbs (son of Sgt. Benjamin Gibbs, *see p. 98*). He was medical orderly and boiler man all his working life. The last big epidemic of smallpox occurred in 1908. On 14 December an infected seaman was admitted. Dr Davies, Senior Medical Officer, isolated him, shadowed all contacts and had them vaccinated, and for five weeks there were no further cases. In the third week of January 1909, a new case was reported and by the middle of April, 36 patients had been admitted of whom seven died. William's wife, Lydia, only saw her husband once every six weeks during this period when he came to their home in Ivy Terrace, Highbury Road, banged on the corrugated iron fence and threw over his wage packet. 'The neighbours used to cross over on the other side of the street when passing our home,' said his daughter, Enid; 'they called it the fever home.' [M20].

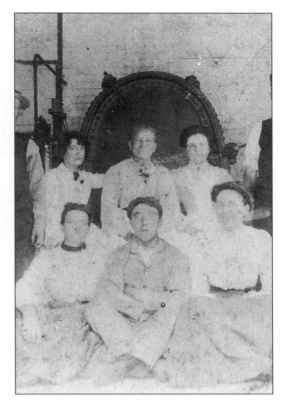

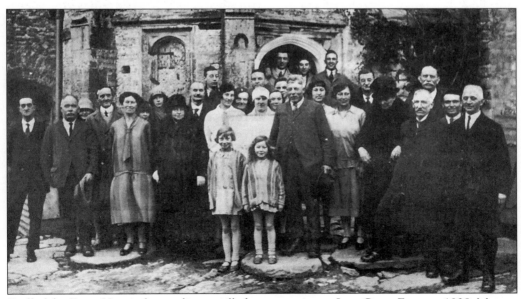

Staff of the Fever Hospital attending a milk demonstration at Inns Court Farm, *c.* 1928. Matron Lane wears a cloche hat and furs; next to her is Nina Childs, her personal maid. William Gibbs, the mortuary attendant, is third from the right. [M12].

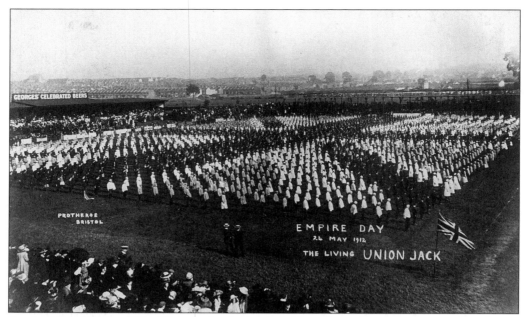

Empire Day, 24 May 1912. Thousands of school children dressed in red, white or blue form a living Union Jack on the City Ground, Ashton Gate. In the distance are the roofs of terraces in the Chessels (left) and the cottages bordering the road climbing Bedminster Down (right).

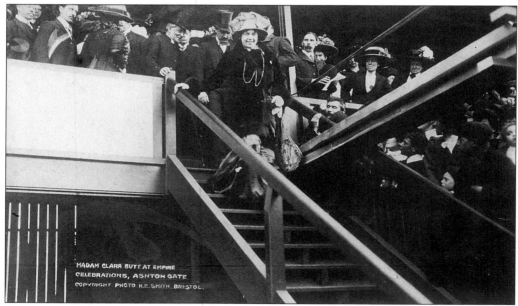

Clara Butt, in her stentorious rendering of *Land of Hope and Glory* at one end of the City Ground, failed to synchronise with the brass band at the other, and for the crowds in between the discord was excruciating. [M27].

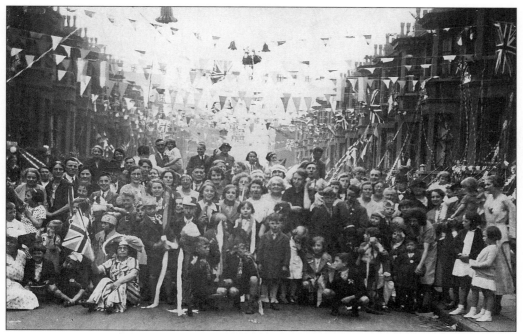

Coronation Day, 1937, in Warden Road. The tightly-knit community of Bedminster demonstrates its solidarity; these scenes were repeated on VE Day, 1945, for the Coronation of Elizabeth II in 1953, and the Silver Jubilee in 1977.

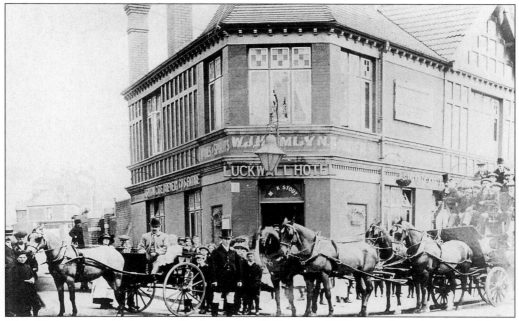

This Christmas-card scene outside the Luckwell Hotel, *c.* 1912, must have been to celebrate some auspicious event, or perhaps an outing of the regulars.

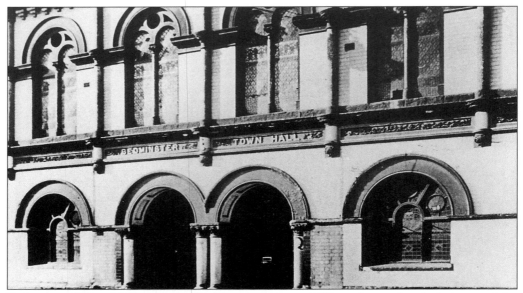

Bedminster Town Hall, Cannon Street, was built in 1892 and was already being used for entertainment; Clara Butt gave her first public performance here in a charity concert before it became Pringles' Picture Palace in 1909. In later years the roof leaked rather badly. Regulars knew where not to sit, and it was not unusual for patrons to open their umbrellas during film shows. The cinema closed in 1954 and the building became a supermarket and is now a furniture store.

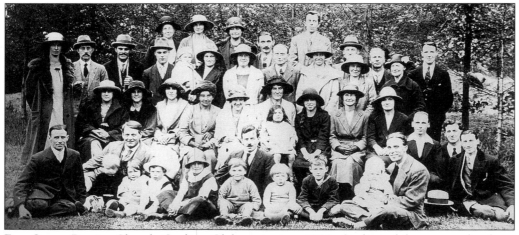

East Street Baptist Church Cycling Club outing, c. 1926. Cycling clubs attracted a large membership and enjoyed a wide range of social activities in addition to cycling. In that unsophisticated age, cycling was the normal weekend recreation for most working people. Will Howe, who went to work at South Liberty Lane Colliery at the age of 16 in 1912, said, 'Sundays, we would get up at 4.30am. Mother would cook a steak and say "Now, get that back!" and off we would go on our push-bikes to Minehead for the day. We would be in Bridgwater by 7 for a drink in the pub, and Minehead by 9. Lovely scenery all the way; a bit of fresh air after the mines. We used to have some fun down there. The girls from Wills' would be there on a charabanc outing. We used to get back about 10.30 at night.' All this on unmetalled roads with no gears.

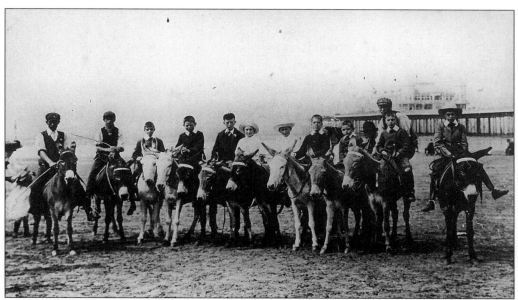

The only holiday most Bedminster children knew was the annual Sunday school outing to Weston or Clevedon. Regularly in June and July, Bedminster station was crammed with children, 'the girls in their white summer dresses, coloured ribbons in their hair, and white blanco-ed sandals on their feet. The boys in their straw-brimmer hats – "Donkey's breakfast" we called them – with cords attached to their blazers to prevent the hats blowing away. The excitement of the train journey and then, marshalled by the Sunday school superintendent and his assistants, the final march to the sea. Then, there it was: the sand and the sun glittering on the waves, the pier, the ice-cream stalls and the donkeys patiently waiting. Fish and chips, amusements on the pier, peepshows and novelties, perhaps a ride on a wagonette to Uphill, the water chute, tea in a church hall and then the march back to the railway station. And then it was over till next year.' [M8, M35, *Water under the Bridge*].

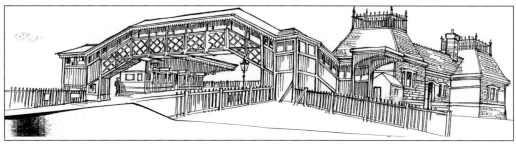

Bedminster station's ornate ticket office and footbridge was built in 1870 and removed in the 1930s for an additional track. In the 1960s all remaining buildings were cleared, leaving only the bare platform.

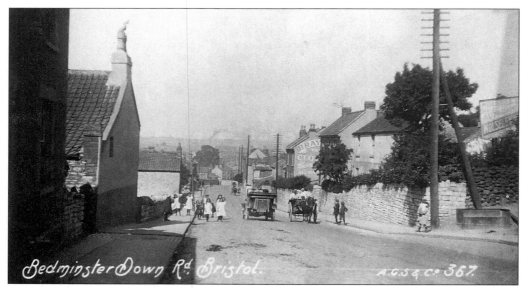

The road to Bedminster Down in 1910 was only half the width it is now, with cottages all the way down the right-hand side. The one shown here, next to the telegraph pole, was a village laundry. The little girls in pinafores are from the Bedminster Down Board School (halfway down on the left, later Bristol South Central School and now business premises) and could quite safely walk in the middle of the road. Only one car is in sight – many were to break down on this hill. Horse manure can be seen on the road, which was occasionally blocked by farmers driving their cattle to market. House-owners had a job to keep them out of their front parlours. [M2].

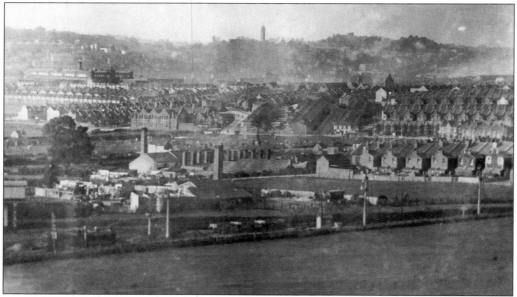

Part of the panorama from Bedminster Down, pre-1914, showing on the right the backyards of Nelson Street in the foreground and a tank engine approaching from Weston. Centre is the tile and brick works in South Liberty Lane and, beyond it, Luckwell School showing the centre block that was destroyed by bombs in the Second World War. [M33, M34].

The old Bedminster Down Bridge, constructed *c.* 1840, was at right-angles to the railway track, and until rebuilt in 1933 presented a major kink in the main road. Miners' cottages and the Miners Arms pub can be seen in the background.

The Telegraph Inn, overlooking the parapet at Bedminster Down railway bridge. This inn was destroyed by bombing during the Second World War. All the other dwellings shown were subsequently pulled down for road widening. [M1].

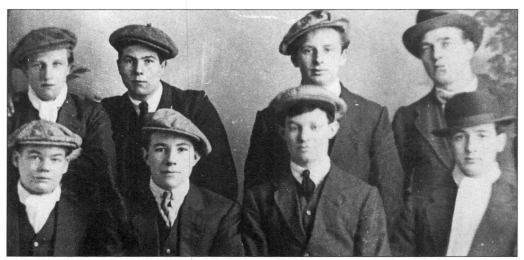

'Bedminster Blinders', c. 1910. The habit of wearing mufflers and pulling their caps over their eyes gave Bedminster Down's denizens in these years a rather colourful reputation. These characters were identified in 1974 by Ted Cox, 'the oldest man on Bedminster Down'. From left to right, back row: Daniel Hill (worked in the lime kiln on Bridgwater Road for Alfred Froud); Roy Yeates (worked for E.S. & A. Robinson); Jim Cox (worked for Robinsons, then Frys; he lived in Avonmouth); George Padfield (worked for Ashton Containers; he was lame and walked with a crutch). Front row: Joe Hall (lost a leg in the First World War; he married the nurse who looked after him and emigrated to Australia); George Wilkins (a good local runner; he won cups. Never had a regular job. Did a bit of hauling and vegetable gardening. He married Ivy, daughter of Harry Godfrey, landlord of the New Inn and was killed when the pub was bombed in 1942); Will Hill (17 years old); Bert Wherlock (worked on the buildings).

The New Inn, Bedminster Down, was a focus of the community until 12 April, 1942, when it received a direct hit from a high-explosive bomb. Mr Harry Godfrey, the landlord, and his pals had come out of the pub to watch the fires raging over Bristol in the famous Good Friday raid when the bomb fell. He and three others were killed in the blast. Other regulars who sheltered under the stairs escaped unscathed. No trace remains of the pub; the site is now part of the front garden of the house called 'Gorgeous View'. Third from left is George Wilkins, son-in-law of the landlord, who was one of those killed.

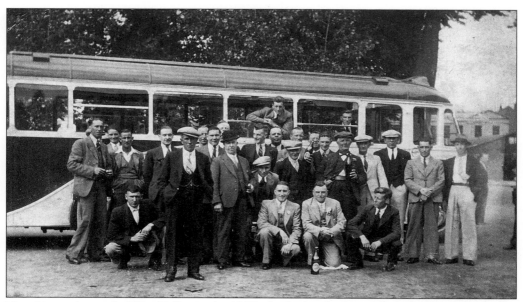

New Inn outing to the Wye Valley in the 1930s. In the bowler hat is Tom Godfrey; holding the bottle, Bob Hall. On the left is Billy Crew; on the right are Mr Bailey and Mr Garland.

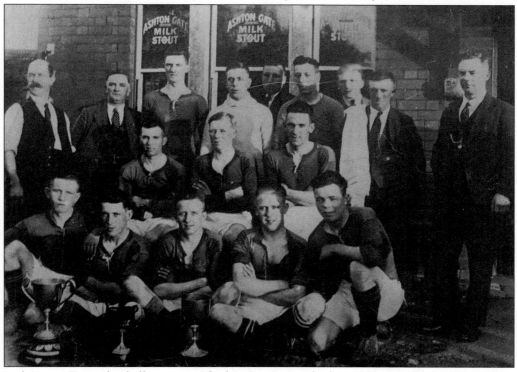

Bedminster Down football team outside the New Inn in the late 1930s. From left to right, back row: Mr Godfrey senior, Jack Kew, Vic Hill, H. Davey, A. Mills, A. Hamlin, J. Hall, B. Crew, A. Bridges (the chairman). Middle row: Harry Kew, Albert 'Muscles' Hall, Ted Chapman. Front row: W. Smith, 'Nipper' Garland, Reg Hall, A. Parker, Bob Hall.

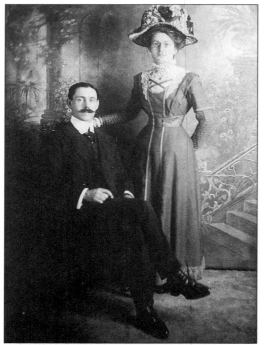

Lily Harvey of Stillhouse Lane first came to know Rifleman Will J. Harris as 'foreign correspondent' for the International Order of Good Templars. Seeing this handsome young man, with his smart uniform and waxed moustache, at the Redcliffe Crescent Methodist Chapel, where the Good Templar meetings were held, she thought to herself, 'He looks the sort of man my mother always warned me against.' So much for mother's advice; they were married on 19 September 1909, at the church where they first met! Rifleman Harris was wounded at the battle of Mons (1914) and was taken prisoner. Late in the war he wrote to Lily, 'Send Golden Syrup.' She took it to mean 'gold in syrup' and sent a gold sovereign in a treacle tin in his next food parcel. She hoped it would help him when he escaped, but he never needed to spend it and wore it on his watch-chain to the end of his life.

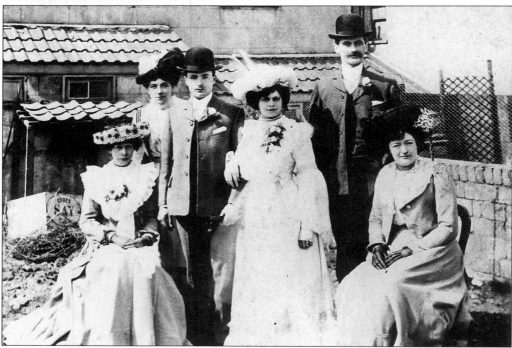

Wedding party in a Totterdown backyard, *c.* 1910. Henry Linah Carr, second from right, who served in the Boer War and kept a diary of the battles, and his sister Rhoda, right, attended the wedding of their younger brother, Frank, We don't know the name of the bride and her family, but their finery makes an astonishing contrast to the very humble backyard behind. [M11, M12].

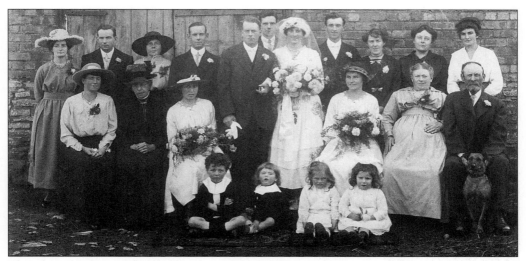

This photograph was taken by Wright and Co., 110/112 East Street, Bedminster. Judging by the fashion, it dates from *c.* 1919.

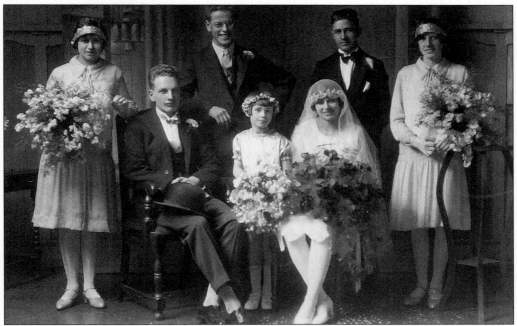

Wedding group assembled for the marriage of Doris Harvey and Leonard Thorne in 1926. This is a typical wedding photograph of the period, taken in the studios of Stanley's the photographers in East Street. From left to right, back row: Will Thorne, Henry Harvey. Front row with the bride and groom: Ivy Harvey (left), Winifred Harris (centre) and Margaret Thorne (right). The bride and bridegroom were both born in Philip Street but Doris moved to the Three Horse Shoes in West Street with her family in 1908 (*see p.* 86). Leonard, son of Rose and Francis Thorne, was brought up with his two brothers and six sisters. They lived at the shop in Philip Street, where his father had a shoemaker's business. When they grew up, Leonard and his older brother, Bert, joined their father in the shoe-repairing trade; they continued the business after his death in 1933.

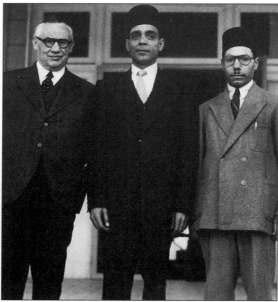

Left: 'Princess Caraboo'. Mary Baker, after her notorious hoax of 1817, spent the rest of her life in poverty and obscurity in Princess Street, East Bedminster, selling leeches to the General Hospital. She died in 1864 and is buried in an unmarked grave in Hebron Road burial ground. [M31]. *Right:* Ernest Bevin, b. 1881, (left) as a lad he drove a dray selling lemonade for a Winford tradesman. He was always ready for a prank. Mr Garland senior gave him a thrashing for 'spragging' his cartwheels, i.e. running a wooden bar between the spokes while in motion. He was deeply involved in the trades union movement becoming a full-time local official, and later transferred to London as General Secretary of the Transport and General Workers Union. In the wartime coalition government he was Minister of Labour under Winston Churchill and, at the time of this photograph, was Foreign Secretary in the post-war Labour government.

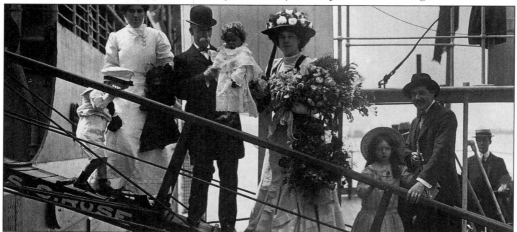

Clara Butt. As a child she lived on Coronation Road and attended Redcliffe Crescent Church (off York Road). Her first public appearance was in the Bedminster Town Hall (then an evangelical mission led by her father) as part of a charity concert. She married Robert Kennerley Rumford at Bristol Cathedral in 1900. She is seen here embarking on a concert tour to Australia in 1907.

Left: Fred Bollom, son of a Whitehouse Lane baker, pioneered the dry-cleaning business, together with brothers Bert and Sam. Fred worked at Wills', Bert was a tailor and Sam worked as a commercial traveller. They invested their joint savings in a pressing machine and opened their first shop in Stapleton Road in 1927. By 1955 there were 200 branches and 'Bollom' had become a household name. [M14]. *Right:* Billy Butlin spent his boyhood travelling with fairground folk whose winter quarters were in Vale Lane. From these small beginnings he built an empire. He took pity on families turned out of seaside lodgings during the day and started the first 'holiday camp'. An early slogan was, 'A week's holiday for a week's wages'.

Left: Ron Cleeve (1913-1989). He was a teacher at Parson Street School for thirty years and St Anne's for ten. A great enthusiast for Bedminster and its history, he compiled the first book on the subject called *My Malago Book*. Produced on primitive school equipment, a copy was awarded to each of his pupils who participated in his favourite scheme – the cleansing of the Malago stream. One season, Ron and his youthful acolytes removed 72 tons of rubbish from the Malago. His enlightened ideas on how to landscape it have, 50 years on, been accepted by the planners and are now partially implemented in the 'Malago Greenway'. *Right:* John Dingle. From very humble beginnings in Totterdown, he established an eating house in East Street and went on to become a gastronomer extraordinary, working as a chef in the Ritz and founding the Hawthorns Hotel. He was a benefactor of the Philip Street Baptist Chapel and Crossways Tabernacle, Bishopsworth. His autobiography is called *A Pinch of Pound Notes*. [M32].

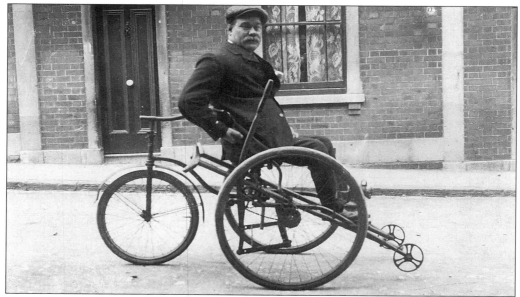

George Sanders (1860-1927) was a well-loved member of the community and, despite having had polio as a child and being unable to walk, lived a very useful life. He is seen here in the invalid chair he designed and made himself with wheels supplied by the local cycle shop. As a shoe-repairer, in the workshop behind his mother's cottage in Stillhouse Lane, he became the friend of young and old. Well-read and better educated than most, he would, in the days when many could not read and write, help by reading and replying to letters in a beautiful copperplate hand. [M27].

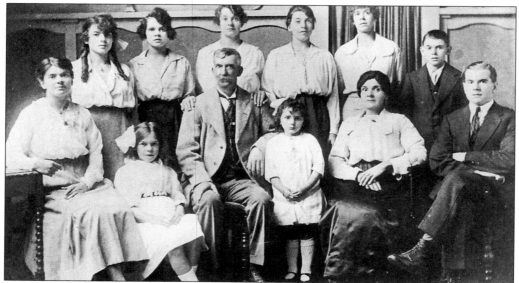

'Professor' Charles Stephens, 'The Demon Barber of Bedminster' (centre) was a born showman and stuntman, jumping out of hot-air balloons, shaving his clients in a lion's cage and daring an American knife thrower to slice in two an apple placed on his throat. He met his death on 13 July, 1920, going over Niagara Falls in a barrel. The barrel was too heavy, fell through the water and smashed in pieces. Only his tattooed arm was recovered. [M20, M32, M33].

Left: Russ Conway. Born Trevor Stanford, 1926, on Coronation Road, he taught himself to play, mostly on the organs of St Paul's and St Mary Redcliffe. After serving in the Royal Navy and Merchant Navy, he achieved world fame as a pianist and composer. In the 1950s and '60s his records were hardly ever out of the Top 20. His *Side-Saddle* reached the number-one spot and continues to be popular. In all he had seventeen consecutive top-twenty hits and is still going strong. *Right:* Reece Winstone. Son of a Bedminster hatter and hosier of East Street, his flair for photography placed on record the profound changes in the city over 40 years and his albums of historic photographs pioneered the sort of visual archives of which this book is a recent example.

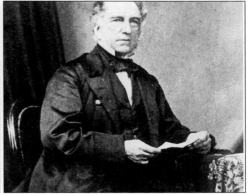

Left: John James. Born to a poverty-stricken family in Philip Street in 1906, he built up a chain of radio and television shops, going on to make money in building, manufacturing and investment. Following the tragic death of his daughter, Dawn, he founded the Dawn James Charitable Trust which has donated huge sums of money to the elderly and to support education and health. He died in 1996 having earned a proud place among the great benefactors of Bristol. *Right:* Robert Phippen JP. A great public figure and possibly Bedminster's most notable personality. He became a solicitor, partner in the firm of Phippen and Craven in Corn Street, a director of the Bristol and Exeter Railway and director of the Bristol Waterworks Company. He was President of the Bedminster Cricket Club, churchwarden of St John's and prime mover in the rebuilding of that church in 1885. At Bristol's first municipal election in 1838 he was returned for Bedminster and was a member of the City Council until his death. He became an Alderman in 1856, was Mayor of Bristol 1840-41, High Sheriff 1854-55 and again 1868-69, when he died in office. Perhaps no-one was more deserving of the title, 'Friend of Bedminster'.

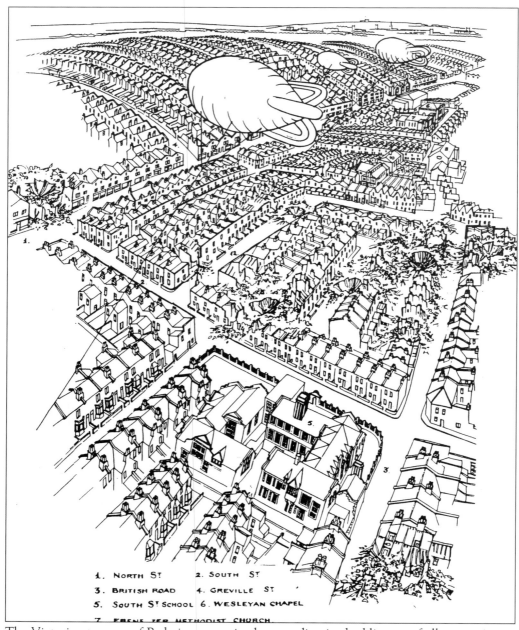

1. NORTH ST 2. SOUTH ST
3. BRITISH ROAD 4. GREVILLE ST
5. SOUTH ST SCHOOL 6. WESLEYAN CHAPEL
7. EBENEZER METHODIST CHURCH

The Victorian terraces of Bedminster received a pounding in the blitz out of all proportion to their strategic and economic importance; it was just Bedminster's misfortune to be on the flight-path between the Dorset coast and the main enemy targets – Temple Meads goods sidings and the Filton aeroplane factories. In the foreground, South Street School, looking north (towards the centre of Bristol) between North Street (left) and British Road (right). Top right-hand corner: the British School, Hebron Methodist Chapel and Sunday School, Ebenezer and Wesleyan Chapel and the roof of the Rex Cinema, North Street. There was such widespread destruction between Gladstone Street and British Road that the whole area was subsequently cleared to make a playing-field for South Street School. [M1].

118

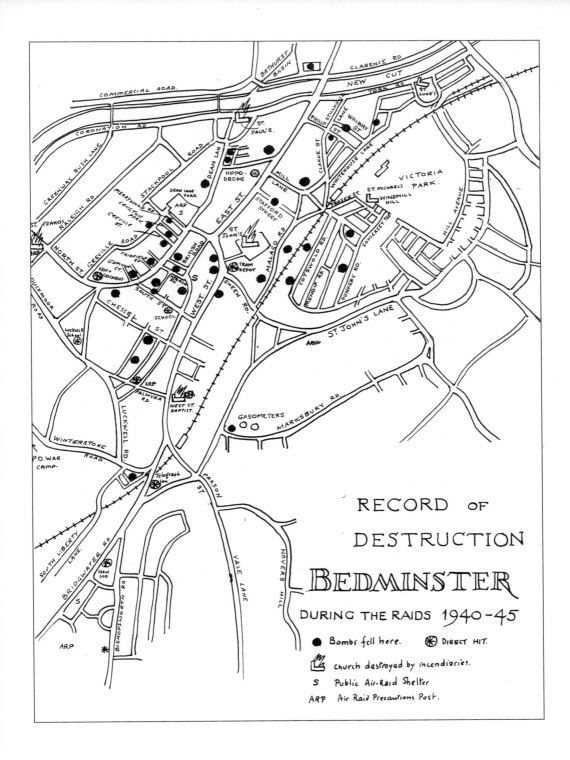

RECORD OF
DESTRUCTION
BEDMINSTER
DURING THE RAIDS 1940-45

● Bombs fell here. ✸ DIRECT HIT.

🏭 church destroyed by incendiaries.

S Public Air-Raid Shelter

ARP Air Raid Precautions Post.

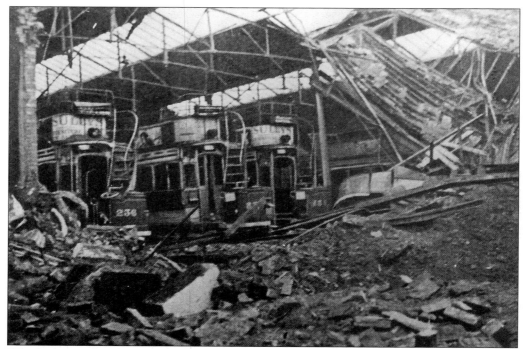

Wrecked tram-depot, junction of Sheene Road and West Street. One tram-driver was killed. This direct hit put all the tram-lines in South Bristol out of action and they were never returned into service. McDonald's car-park now occupies this site.

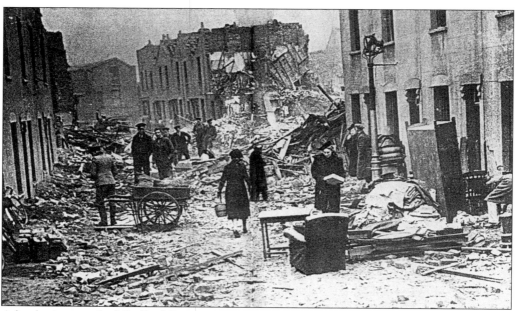

A land-mine wrecked Stafford Street.

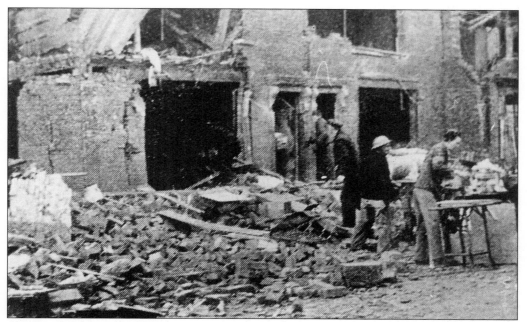

Bombs in South Street completely severed gas, water and electricity supplies and hardly a house escaped damage; many were totally destroyed. The population spent a ghastly night (Good Friday, 1941) in air-raid shelters hastily improvised in back-gardens only the week before. The next morning at 8.30am, as people began picking themselves up, they suffered the added terror of an unexploded bomb at the lower end of the street suddenly detonating. An old lady who had been walking up the street on the other side was the only casualty.

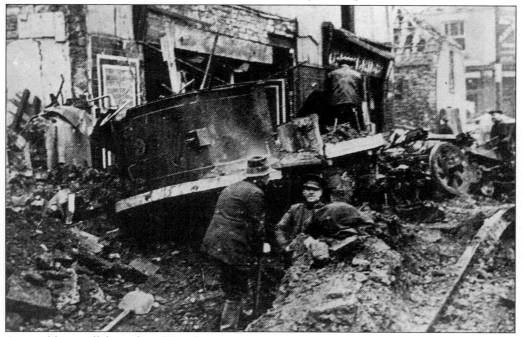

A tram blown off the rails at West Street.

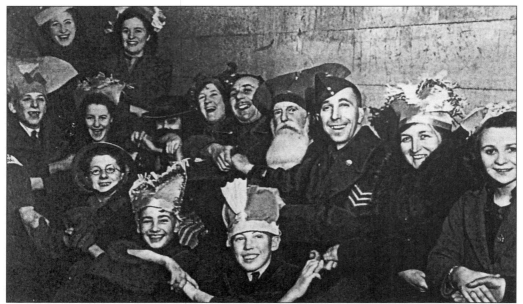

Christmas 1940. The *Evening Post* took this photograph of a party in an air-raid shelter. These Bedminster folk look happy enough, but public surface air-raid shelters were notoriously un-bomb-proof. Some collapsed with no bombs coming anywhere near them. One Bedminster ARP warden found a packed air-raid shelter in which every person was sitting bolt-upright with their eyes open, but dead – killed by the blast. Many families preferred to take refuge in Dundry or Chew Valley, some even travelling every night to camp in Brockley Combe.

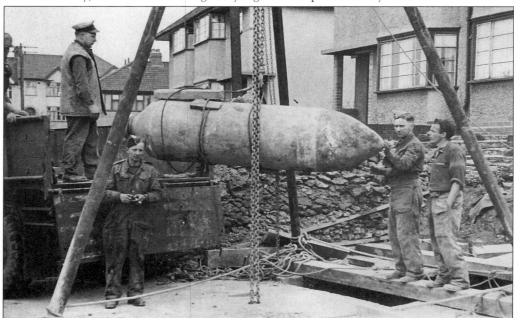

'Satan', the largest bomb dropped in Bristol. It landed in Beckington Road off St John's Lane on 3 January 1941, but failed to detonate on impact. It lay undiscovered until it was removed in April 1943. It was 8 ft 11 inches long and contained 4,000 lb of explosive.

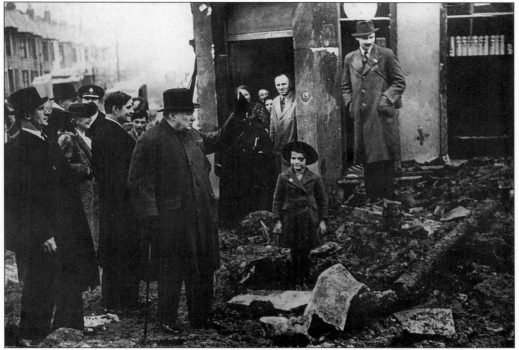

Mr Churchill came to Bristol in 1941 and is seen here outside the shop of Mr S.W. Pitman at the junction of Raleigh Road and Leighton Road, Southville. The little girl is Anne Shepherd who lived in Leighton Road immediately behind Pitman's.

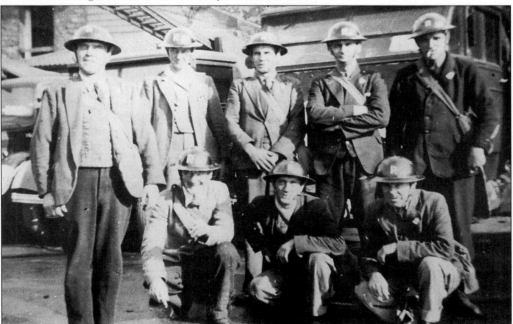

ARP wardens, Ashton Gate. Mr Vic Hill gave us this photograph but unfortunately he died (1996) before he could tell us any names. Perhaps our readers will.

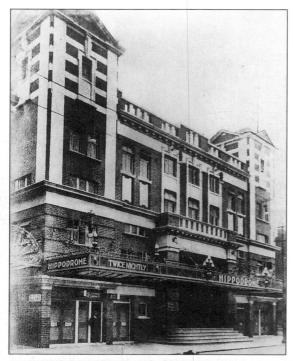

Bedminster Hippodrome. This monumental façade once dominated East Street. It was opened in 1911 as a variety theatre, but became the Stoll Picture Palace soon afterwards. It was a place of popular entertainment for a whole generation; you could have a night out for 6d in those days: 1d for the tram from the Miner's Arms, 2d for a seat in the gods, 2d for faggots and peas afterwards and 1d for your return fare. Russ Conway remembers 'the glamour and mystery of the silver screen; the distraught manager closing down the film, leaving a well-lit but blank screen and telling us to shut up. And we did get the film back, but then started yelling again. Orange peel and peanut casings trampled on all over the floor ... ice cream packs if we could afford it ...'.

It was customary for the staff to be dressed in costumes relating to the film being shown. Here are Edna Simmons of Prospect Place, Sion Road and the other usherettes in Chinese costume to advertise *Daughter of the Dragon*. Other well-remembered films of the 1930s were *The Robe*, and *The Sign of the Cross*. There was a continuous performance from 2.00pm till 10.30pm with an interval for a variety turn by people such as Tessie O'Shea or Randolph Sutton, a popular Bristol-born star. Mr Higgs, the manager, may also be in this photograph. He later became manager of the Bristol Hippodrome and took Edna's sister, Olive (now Mrs Baker), who had been an usherette with him, to work as cashier at the new cinema.

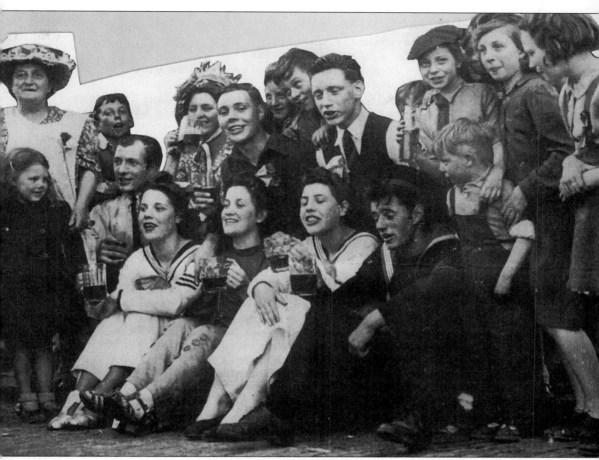

Bedminster suffered more damage than any other part of Bristol. When the war ended there was a spontaneous explosion of relief. Food hoarded for months was lavished in hastily improvised street parties. Ted Hill, aged 11, was playing as usual with his mates among the debris of South Street. "'Let's light a fire," said a voice; "the war's over; it's not illegal". We found paper and bits of wood and soon had a fire going. Mr Whitlock came out. "Here," he shouted, "you can burn this." It was half a barrel-full of static water! We helped him empty it and pushed the barrel into the fire. Suddenly it seemed grown-ups were coming from everywhere, bringing things to burn. Our fire grew rapidly into a regular bonfire. I ran home; "Come on," I yelled, "we've got a bonfire, everyone's there." "Alright," said mother, "but have supper first". I gulped my supper; as we opened the door, the sound of singing, shouting and laughing came to us. At least 200 people were there; all around the fire people had joined hands in a huge hokey-cokey ... we joined in.' This photograph was taken outside the Maltsters in Philip Street (now the Apple Tree).

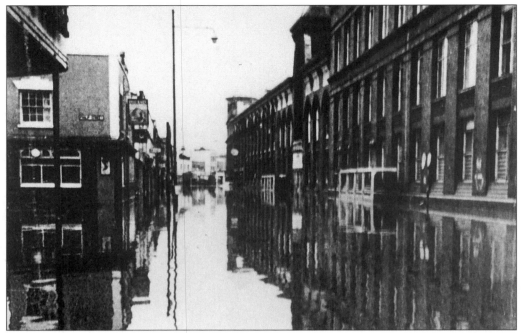

On the night of 10 July 1968, 6.8 inches of rain fell in $6\frac{1}{2}$ hours. The lower parts of Bedminster and Ashton Gate were flooded to a depth of 6ft in places. East Street could have been mistaken for Venice, except for the large pieces of office furniture and television sets floating by, and the smell of millions of packets of rotting cigarettes from W.D. & H.O. Wills'.

Iris and Eunice Thwaites (inset) who kept the Barley Mow public house were just about to close for the night when the flood-water arrived. At first they tried plugging the gaps round the doors; the regulars waded across East Street to catch the last bus, but, ploughing through the water like a tank, it dared not stop. At the last moment a tidal wave came down Philip Street, pinning the regulars against the wall of Wills' up to their armpits. They struggled back to the Barley Mow. The ground floor was now awash; Eunice Thwaites grabbed a bottle of whisky and they all fled upstairs and managed to pass a rather uncomfortable night in chairs.

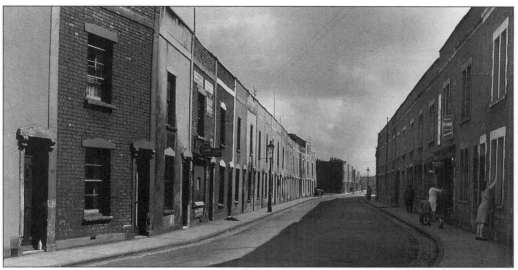

The Second World War delayed redevelopment of Bedminster and not until the 1960s were acres of nineteenth-century terraced houses demolished and the occupants resettled. In 1883 there were 29 houses in Doveton Street, 31 in Clarke Street, 35 in Willway Street, 51 in Whitehouse Lane (shown here), 66 in Stillhouse Lane, 71 in Percy Street and 93 in Philip Street. In 1990 only six houses remained in Whitehouse Lane, six in Stillhouse Lane, five in Philip Street, two in Doveton Street and none at all in Clarke Street, Willway Street and Percy Street. In the 1960s dwellings in St Luke's parish also disappeared: St Luke's Road, Spring Street, Mead Street, Princess Street, etc. The area is now an industrial estate.

One famous landmark to disappear in the 1960s was the 'White House' which gave Whitehouse Street and Whitehouse Lane their names. It stood at the junction of the two, next to the railway arch, and dated from the eighteenth century, or even earlier, long before the railway, when all this part of Bedminster was open fields. In 1842 when the Bristol and Exeter Railway Company cut right through the property the 'White House' found itself embedded in the railway embankment. It lost its ornamental gardens *c.* 1890 when the last houses were built in Whitehouse Lane. Its last occupant, Bert Frape, then aged 92, recorded his memories of the White House in the first number of *Remember Bedminster* (spring 1988), published by the Memories Group composed of ex-residents of Clarke Street, Philip Street, Whitehouse Lane, Percy Street and Doveton Street who attended a reunion organised by the Windmill Hill City Farm which was started on the site in 1976 and brought life back to this derelict site; the Memories Group have met regularly ever since, and in 1997 published their 21st *Remember Bedminster*.

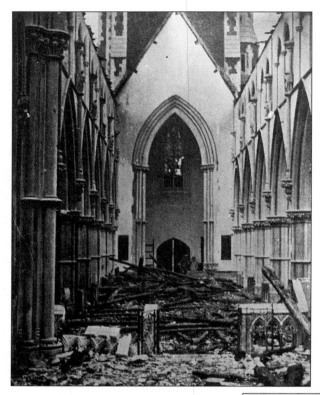

The Church Commissioners, in their wisdom, decided not rebuild the parish church of St John the Baptist. That noble edifice remained a gutted shell after being burnt out in the blitz (1941).

The ruins were judged unsafe and in 1967 were demolished although for days the tower resisted the assault of a huge metal ball on a chain. The 1855 building had incorporated the masonry of the 1665 tower and that contained considerable fragments of much older belfries, including a ninth-century Saxon window. Not even the foundations of the church remained in an overgrown and vandalised churchyard which became an eyesore from illegal tipping and unofficial bonfires. In the 1980s the headstones were recovered and removed; the site was landscaped and fringed with imaginative new housing. From time to time the neighbouring parishes, which took over the responsibilities of St John's, hold open-air services on the site on the day of the patronal festival in June – a touching and deeply significant tribute to the fact that, on this spot some 1,500 years ago, Bedminster began.

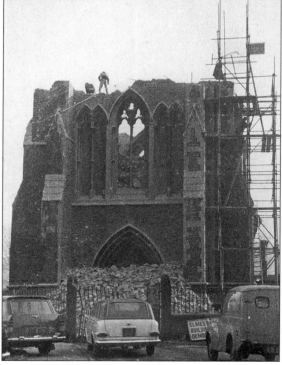